"I was thinking of a book,
but I didn't like that idea"

Marcel Duchamp (to J. J. Sweeney)

lovingly
Rrose Sélavy
alias Marcel Duchamp

Duchamp's
TRANS/*formers*

A book by
Jean-François Lyotard

Incongruences

Declaration

I don't say that what follows is all false, nor that it's all true, nor that it's neither false nor true nor both-true-and-false, nor a bit false and a bit true. But could it be that Monsieur Duchamp sought and obtained, or that Mlle Sélavy sought and obtained, *contrariety* in the matter of space and time and in the matter of matter and form? You prefer to say *incommensurability?*

Complaint

I protest that there is no being more sententious than M. Marcel. He reaches the height of sententiousness, each of his enigmatic sentences lays down a *sententia* in each of his strange little jottings. Such is his hardness. Whose hardness? The hardness of Monsieur Marcel's sentence or product? Or Monsieur Marcel's own hardness? He's tricked us with his hard and sentential sentence. He has asphyxiated us. You can't say anything anymore. But seeing?

Seeing no more than saying. The *Large Glass,*[1] nothing to see, transparent. *Given,*[2] nothing to be seen but a vulva, and for that reason nothing but a cunt to see with.

Amendment

But no, it's the opposite. His hardness does not come from the sententiousness of his sentences and products, it comes from their obscurity. Or even from the obscurity of their destination. Do you know where it's all going? All what? Do you know where these sentences are leading? To lead, to go? Do you know what purpose they have, what end they aim for? Well, I don't see any except for one: to make us speak. To make us ask each other, or ourselves, about it. It leads us to make commentary on it. His highly obscure sentence calls for our sentences to comment sen-

[1] *The Bride stripped bare by her Bachelors, even (The Large Glass)*
La Mariée mise à nu par ces Célibataires, même (Le Grand Verre)
(1912, Paris; 1915–23, New York).

[2] *Given: 1. The Waterfall, 2. The Illuminating Gas*
Etant donnés: 1° la chute d'eau, 2° le gaz d'éclairage
(1946–1966, New York).

tentiously on his sentence. Hence the proliferation of wordy *sententiae,* and what's the harm? No harm, no good, and no neither-nor either. By being elusive, through their obscurity, his sentences attract ours to come forth and add themselves on. Thus we are constrained to be much more phrasey [*phraseurs*] than Monsieur Marcel. And as for seeing, it's the same thing. You put your eyes in the holes in the Spanish gate, you see a vulva all lit up by a 150-watt spotlight, hairless, and you think you see whatever you want to see. So what did you want to see through the holes in the door? That's just it, after seeing this female hole, you don't know anymore. That and not that. You thought you had wanted to see that, but you notice that you no longer want to think so. Holes onto a hole. What's there to see about a hole? A hole, says Mademoiselle Sélavy, is made for seeing, not for being seen. For looking through, that's what a hole is. An opening, and perspicacity. So what did you see? Something to see with.

Didactics

This idea can easily be grasped by the looker: by inverting the top and the bottom of the picture of the study (1948–49) for *Given,* he can't fail to perceive the profile of a

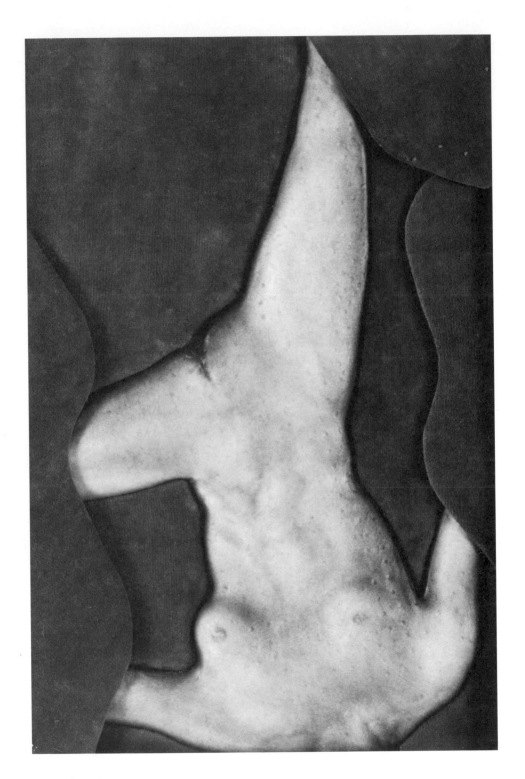

Marcel Duchamp
Study (New York, 1948–49) for
Etant donnés.
(Shown here inverted.)
Moderna Museet, Stockholm.

Mr. Punch, whose nose is formed by the cut-off left thigh and the hooked chin by the left arm, which is likewise truncated, and the runaway mouth by the shadow thrown by the left breast on the chest, and the narrow eye-slit by the cunt. And if he worries about the legitimacy of our Method, let him take courage by referring to the Wilson-Lincoln System (DDS, 93),[3] which consists in drawing with a single line two dissimilar profiles, imbricated, it is true, not according to the vertical axis of the top and the bottom as here, but according to the horizontal axis of the right and left.

The Punch-figure of course is looking up, unlike the cunt; he's its opposite partner, like the spectator of *Given.*

Objections

This Method is unworkable for *Given,* the posthumous work, which can't be turned upside down at all, contrary

[3] The references noted as DDS refer to Marcel Duchamp, *Duchamp du signe, écrits,* new edition revised and augmented by Michel Sanouillet with the collaboration of Elmer Peterson, Paris, Flammarion, 1975.

to the 1949 object. I can't see anything there other than a cunt. And besides, the method is that of a sententious man. . . . It thinks it shows and explains what's there to be seen and taken from this cunt. It thinks it can get on top of Monsieur Marcel. It doesn't realize his hardness. It softens it. I bet it will end up saying: What you see from your door-holes is Mademoiselle Rrose, naked, hosing you with her waterfall; what you see in my inverted image is Monsieur Marcel, the man from the gas company. You'll say: But, but . . . it's already Bataille's eye. . . . And all's well. In the third place, the method is phrasey. It makes a work. You have inverted the image of the Woman, how clever you are, etc. We've made progress, etc. You found a man in the woman. We see, we get it. . . . And yet, you're still behind your door, looking at / like a cunt.

Chorus

Either he's depriving us of air, or else he's imposing an air on us. We're playing professors because Monsieur Marcel hasn't professed anything, or hardly anything. He's irksome, but aside from that you mustn't think you've won just because you've discovered that. Better not bother with him.

Diagnostic

So what will you do? These are the little setbacks of the critic. Is it always hard and irksome? Not always, but it is so here because Monsieur Marcel has the critic in his sights to defy him and poke fun at him. You won't get me, that's his obsession. It's me, Marcel, says Rrose. I am Rrose, says Marcel. I'm staying celibate, says the Bride. I'm still married, says the Bachelor. I have two dimensions, says the plate of *Glass,* but its transparency says: there are three. . . . I have three dimensions, says the lower region. I have at least four, says the upper region. I'm a horizon line in a perspective view, says one transverse line of glass; I'm the lower edge of a geometral plot, says the other. Perhaps I am an elevation in this geometral space, says the *Pendu femelle,* and maybe I'm its plane view, says the Milky Way.

Didactics

In this spirit of defiance or uncertainty our reader and spectator will be inspired to consider attentively the body of the Woman in *Given.* He will notice that the right breast and shoulder are those of a man, and especially that between the vulva and the right of the groin, a swelling

suggests the birth of a scrotum. If he masks one side at a time, he'll be convinced that the right half of the body is male, the left half female. It won't help to imagine an outline of a female bottom instead of a scrotum: the argument shifts: don't boys press their genitals between their legs to fake a slit? You're joking: the thighs here aren't exactly pressed together.

Objection

There you are, caught again by commentary.
—description, rather. . . ? It's the same thing: If you describe, it's to show what wouldn't have been seen without you, so you add yours words to the visible. You describe androgyny, hence you comment on duplicity. You're playing the cleverness game. And then what? Don't they still slip away, Monsieur Marcel and Mademoiselle Rrose? Yes, they get away. Perhaps there isn't such a thing as the visible at all. Merely phrases. The work of this Sir-and-Madam resides solely in scribblings on bits of paper in the Boxes, ingenious projects in the style of Leonardo; but maybe a Leonardo who is sick and tired of glue?

Resolution

Thus it's necessary to be conscientious and phrasey as always, and hide the one important thing, namely, that you're interested by Duchamp in inverse proportion to the amount you've understood about him and the amount he's made you think (comment on). I don't mean: it's a world, this enormous work; you could spend years in it, so many journeys to make in order to get through it, etc. On the contrary, the work is very slight, and lightly armed, *opus expeditum*. He wasn't a chief of staff, rather a phlegmatic irregular. Each time you comment on him, you raise him one notch in the hierarchy of cultural (= military) powers, and you lose him. There remains something uncommentable, to save him. But don't think you can be saved by joining him. This uncommentable thing has nothing mystical about it: it's simply the incommensurable brought back into commentary. Commentary will perforce be incongruent with the work.

Amendment

You'd have to think of a counter-ruse: In what you say about Duchamp, the aim would be not to try to understand and to show what you've understood, but rather the opposite, to try not to understand and to show that you haven't understood. No, not what you think, not a commentary on incomprehensibility in general or in particular, the seven hundred and twenty-eighth modern text on modernity as the experience of Nothing. No, to be good and conscientious and phrasey, to stick to the motif, to be technical if necessary, and at the same time to let the inconsistency of the commentary and its object be felt, by Yours Truly and by Monsieur Marcel, and by the one with the other, but a conquered inconsistency, you see, not received in disappointment, nor exhibited as a cardinal virtue of martyrdom, on the contrary, nonsense as the most precious treasure.

Amendment

Inconsistency is not insignificance. The latter can be likeable, can solicit our tender feelings, take on the allure of

taste or doctrine. That is, commentary of the body or the mind, when taking insignificance as its object, forgets it for its own account. You begin to live and think according to non-sense, to practice it and commemorate it. The tender feelings you have for it begin to give it meaning, to make it into a raison d'être and a cause to propagate. This is what happened to Dada, to some extent, which is why Duchamp was unable to be a Dadaist. There's where the hardness of inconsistency intervenes, in order to resist tastes and reasons, good or bad, to resist continuities. Sweeney asks how it's done; Duchamp replies: "By the use of mechanical techniques." (DDS, 181) It's not that you love what is inhuman in a machine for its own sake, you love the way its logic, coldly carried out, and distant, lets you discover in this nonsense that you're in danger of loving for itself, this woman, this sun in the water, this street, all of them senseless, with still more strength, humor, and monstrosity. The conclusion is that you have to speak mechanically about Duchamp, as a machine-like phrasemaker.

Apology

Q.—In this regard, didn't you once go so far as to write that there was a pleasure of the worker at his machine? An appetite for servitude? That seemed a bit too easy.

A.—I'm very glad you asked me that question, especially in connection with the mechanics in Duchamp. A general example that I cited caused a scandal: that of the formation of the English working class in the 19th century. Another example, by contrast, was given by a celebrated ear-specialist; the example of a worker whose auditory perception was hardly affected by the noise of the machine on which he was working went unnoticed, even though the frequency was of the order of 20,000 Hz. Through these two examples, deliberately taken from incomparable measures, the point was to convey that there is in the hardest working-class condition an impressive contribution that easily matches, and perhaps exceeds, the adventures of poets, painters, musicians, mathematicians, physicists, and the boldest tinkerers and tamperers.

Q.—A contribution to what?

A.—To the demeasurement of what was held to be the human, to the toleration of situations that were thought to be intolerable. What was demanded was another body, in a different space, that of the mines and workshops, with different rhythms and postures, those commanded by the serving of the machines, on a different scale, that of capital, constrained to another language, that of industry, and to a new sensibility made up of little strange montages like this auditory field neutralized in the 20,000-Hz band. In particular an experience of quantity, unexampled in the rural tradition. I put a lot of emphasis on quantities.

Q.—And it seems you dared to invoke the *jouissance* felt by such a subject, who is the subject of exploitation and servitude.

A.—The old European peasant-aristocrat body cracking and falling to pieces, according to the demands of a different mentality and a different sensorium, of which nobody knew the present or future nature: that made an enormous indraft that sucked everybody up.

Q.—The industrial revolution, as banal as that?

A.—Yes, and hence an extreme intensity, if it was going to be the revolution that put an end to the neolithic concepts of body, space, time, and logic. Not only in the heads of bankers, manufacturers, and engineers, but in the heads and bodies of workers. If you describe the workers' fate exclusively in terms of alienation, exploitation, and poverty, you present them as victims who only suffered passively the whole process and who only gained credence on the strength of later reparations (socialism). You miss the essential, which isn't the growth of the forces of production at any price, nor even the death of many workers, as Marx often says with a cynicism adorned with Darwinism. You miss the energy that later spread through the arts and sciences, the jubilation and the pain of discovering that you can hold out (live, work, think, be affected) in a place where it had been judged senseless to do so. Indifference to sense, hardness. Something that Machiavelli reserved for the Prince, *virtù*.

Q.—Go on, say that there is such a thing as industrial asceticism . . .

A.—I'm talking about a mechanical asceticism. The pro-
letariat, in being subjected to it, contributed to moder-
nity. It is inaccurate and foolish to see them as cattle who
couldn't enter the future except backwards and under a
hail of blows.

**Q.—So you think it's a matter of indifference whether
this asceticism be forced or voluntary . . .**

A.—You mean: For the worker there is no escape from this
hardness; but an artist escapes whenever he likes. He can
remake himself in the tenderness of everyday life. You
mean: The unbearable is not the mechanical; it's the indus-
trial, the inhumanness of the mechanical and its perpetual
exclusivity reserved for the skilled and unskilled laborer.

**Q.—I'll say even more: You dared to say that they enjoyed
the imposed destruction of their old bodies.**

A.—This is very unwelcome in these times of "libera-
tion," the idea that something intense happens to you
without your having wanted it. This is taken as praise of
dependency, which by a slight and natural slippage into

political matters is understood as an apology for servitude. If you add a dash of enjoyment, you're finished: you're caught commending the will to be enslaved. And you've been asking for it, all right: You've claimed to describe social and political facts in terms of affects, a stupid and reactionary project that takes us back to Hobbes and Machiavelli, not to mention Thucydides! Reason alone is progressive, right? If history is not in vain, it must have meaning, and if it has a meaning, there are reasons or causes or signifiers assignable to the facts. Your "enjoyment" felt here and there by such and such a historical subject, really we don't give a damn about it. Your English workers, why don't you come right out and say it, they were happy pulling their wagons on all fours in the coal mines, that's what they wanted? We know this kind of talk, etc.

Q.—Stop it. Give me an answer.

A.—Certainly not. *"Jouissance."* The French think it means the euphoria that follows a meal washed down with Beaujolais. Proletarianization as prostitution, they don't believe that's in Marx; it's only a literary metaphor. In any case there must not be enjoyment in prostituting yourself. And especially not in being forced to it. Here misprision is at its height, and also the contempt. Let's forget it. The

hardness of which we speak is this: Pushed, seduced into factories, into mines, the ex-peasants are placed before an unacceptable challenge, for instance, to work with a 20,000-Hz noise in their ears. They accept it. How? By transforming their bodies; for example, the noise gets neutralized in their auditory spectrum. The metamorphosis of bodies and minds happens in excitement, violence, a kind of madness (I have called it hysteria, among other things). It includes outrageousness, immoderation, excessiveness, when there is no common measure between what you're coming from (the old body) and where you're going. Always incommensurability, here in the projection of the human figure, starting from a familiar space, on to another space, an unknown one. To accept that is to extend your power. This is the hardness of which Duchamp takes a reading, in his way, in his corner. End of my apology.

Q.—No, a word on what is definitive about hardness for the worker and yet provisional for the artist.

A.—A word: this difference is obvious. It is why a minimum of social policy is the commutation of persons to posts and to types of work: polytechnicism. Just what we've been proposing in our little teachings since 1955.

Q.—What an aesthete you are!

A.—A note from 1913 will answer that very adequately: *"the figuration of a possible* (not as the opposite of impossible nor as relative to the probable nor as subordinated to the likely). *The possible* is only a *physical 'corrosive'* (like vitriol) that burns away all aesthetics and all callistics." (DDS, 104) I add: that burns away all politics, as implied by your questions.

Millimetered complement

This hardness (a) is that of descriptions, and (b) it implies humor. When you assemble a mechanism you have to establish as precisely as possible a diagram of it, its complete geometral plan, end elevation, and front elevation. Duchamp practices this descriptive geometry on millimeter-squared paper in the same way as a technical draftsman; and he practices the clockwork that accompanies it in the same way as a toolmaker. Between the plans thrown down on paper in the infinitive form and the finished works there are the studies, and just before the studies, the projection-sketches. We have a millimetered

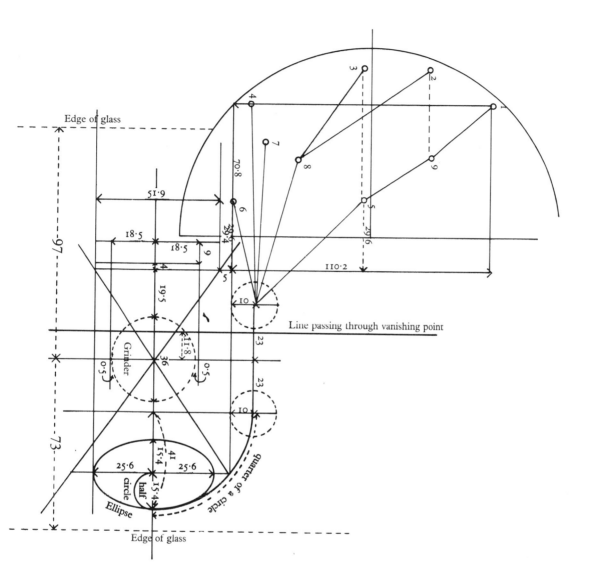

Edge of glass

51·9

18·5

18·5

70·8

39·4

29·6

110·2

19·5

0·5

Grinder

0·5

Line passing through vanishing point

23

23

10

quarter of a circle

41

15·4

25·6

15·4

25·6

circle

half

Ellipse

Edge of glass

**Bachelor Apparatus—
Elevation (1913)
Reprinted by permission of
Hansjörg Mayer, London &
Jaap Rietman, Inc., New York.**

plan and elevation of the Bachelor apparatus; and of the rooms of *Given* as well. These constraints of space and time are not games but contracts made between the mind and its plastic expressions, and it's the body, the habitual, instituted, neolithic body, as it represents itself to itself in terms of its supposed identity, that bears the brunt.

It's going to have to put itself at the unmeasure of what's been thought and noted down, if it is to develop; let it exceed its givens; let it invent its possibilities. When Duchamp reflects on the possible, it isn't like a modality opposable to others, but like a detergent that washes away habits, like a revulsant that evacuates the established facts. That the *Large Glass* should be an automobile machine, or rather its "hood" (DDS, 247); is not a metaphor; it's a method of dissimilation.

Hilarious supplement

As for humor, would I treat it seriously? It resides in the conviction that these laws imposed on the eye, on movement, these bizarre constraints, are not natural, that they are arbitrary, random, "precise, but inexact" (as Du-

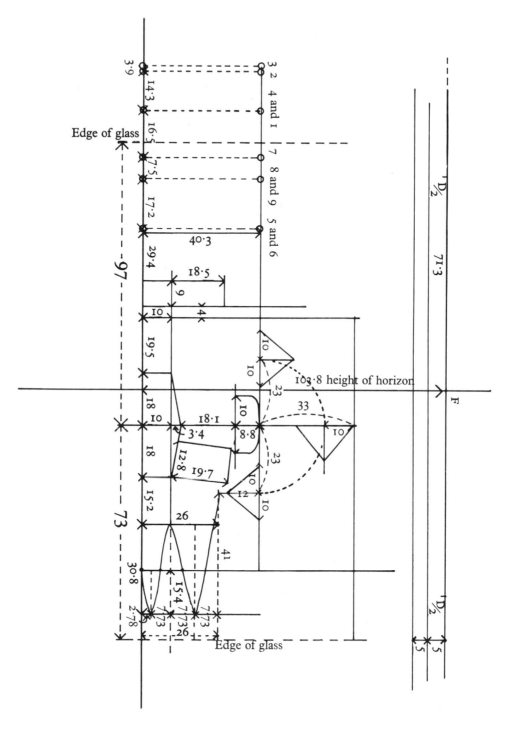

Bachelor Apparatus—
Plan (1913)
Reprinted by permission of
Hansjörg Mayer, London &
Jaap Rietman, Inc., New York.

champ says to Steefel), without any assignable reference.
A self-referring law, a contract with oneself. Add this too:
From the fact that the law is itself not legitimate, not regu-
lated by a beyond of the law, by an omnipotence, an
omni-goodness, an omni-order, comes the result that you
have no guarantee of conforming to it. God must be good
indeed if he is not going to mock you by saying to you,
once you've carried out his orders: Misdeal! that isn't what
I meant, nor is it what you had to do. Thus there will be,
if God is not good but cunning, or if he is not at all, or
if he is several different gods all mutually jealous of one
another, there will be between the establishment of the
contracts (projects) and their accomplishment (carrying
out of the works) a sort of play in the mechanical sense,
which has the result that you'll never know whether the
artist observed the plan exactly that the work is good or
perhaps, on the contrary, bad, or whether something hap-
pened that wasn't provided for in the contract that the
work is bad or on the contrary good. What's going on here
is like sanctity for the Hassidim: the most perfect is per-
haps the most damned, and the most ignoble, the most
healthy. The jolt of the truck that cracked the *Glass* while
crossing Connecticut fifty years ago was taken as a stroke
of grace, not as the *coup de grâce.*

Rectification

You're acting hilarious, but overall you are as serious as can be. You're giving us Duchamp as a model of political thought. To compare his fripperies with the sufferings of the workers. I won't even ask what sane man sees in the *Large Glass* the model of republican socialist thought, or in the diorama of *Given* the picture of a future for the masses. In short, there is no need to prove this absurdity. But allow me to remark that they are at least inconsistent with the previous ones, which opted for non-sense: these latter, at present, overload Duchamp, and his use of mechanisms, with an enormous ballast of meanings attached, in a confused way to tell the truth, to the technological revolution of the past two centuries. That indeed makes sense, when one has chosen to take the side of inconsistency.

Exordium

Innocent is he who thinks you can stand in inconsistency as you might stand in seriousness: i.e., consistently. You must hold yourself inconsistently in inconsistence, and

mix segments of consistency in with it, and make them indiscernible from the others. You'll see that the whole of Duchamp turns upon this academic question of indiscernibles, which also bears the name "question of incongruents" in geometry. This question forms the articulation point of the four studies that are brought together here: it forms their common hinge, for better or for worse, with encroachments, repetitions, and also "contradictions." They are the record of work done along the way, in 1974, 1975, 1976, rather than a single exposition of the results. Later you'll discover in them a kind of stubbornness about making the study of Duchamp begin from that field of impossible superpositions, strange projections, special turning points, anamorphoses, incongruences, which provided material for the *Analysis situs,* for topology, that is, for a sort of reasoning about sizes that forbids itself the hypothesis (the facility) of their commensurability. This stubbornness was justified, with regard to Duchamp, by the results that real researchers obtained during the same period. I'm thinking in particular of Jean Clair and Ulf Linde. However, this would not be enough to justify the publication of the sketches that follow.

But if you consent to take them as contributions not only to an aesthetics but to a topological politics, then you'll

have discovered the intention of Yours Truly. Which means what? You know that the democratic principle and its constitutional implementation, of whatever variety, is indissociable from a representation of space and sizes in space such that this space, i.e., the space of politics, is assumed to be homogeneous and isomorphic in all its points, and that all sizes found in it are judged to be commensurable: it is on this foundation of Euclidean geometry that the idea of democratic equality rests, each citizen being, in such a hypothesis, indiscernible from any other.

But the discovery of incongruences and incommensurabilities, if one brings it back from the space of the geometrist to that of the citizen, obliges us to reconsider the most unconscious axioms of political thought and practice. If the citizens are not indiscernible, if they are, for instance, both symmetrical in relation to a point (the center, which is the law) and nevertheless non-superimposable on one another (as we know is the case for the owners or bureaucrats of capital and the sellers of labor power, as we know is the case for men and women, for whites and "colored people," for urbanites and provincials, for young people and adults), then your representation of political space is very embarrassed. And if you haven't despaired of your life on the pretext that all justice

was lost when incommensurability was lost, if you haven't gone running to hide your ignoble distress beneath the authority of a great signifier capable of restoring this geometry, if on the contrary you think, like Yours Truly, that it's the right moment to render this geometry totally invalid, to hasten its decay and to invent a topological justice, well then, you've already understood what a Philistine could be doing searching among the little notes and improvisations of Duchamp: materials, tools, and weapons for a politics of incommensurables.

15 August 1976 and 15 February 1977

Duchamp as a transformer

These remarks were presented at a panel discussion on Duchamp at a colloquium "On the Performance" organized in Milwaukee, Wis., in November 1976, by Michel Benamou.

Like everyone else, I have problems with the words *performance, performer.* On the other hand, a phrase like "Duchamp as a transformer" seems to me comprehensible. I propose to replace *performer* by *transformer.*

Let's take, for instance, the fabrication of the *Standard Stoppages*:

"If a straight horizontal thread one metre long falls from a height of one metre on to a horizontal plane, deforming itself *at its own free will* and gives a new figure of the unit of length." (DDS, 36) What's important in this operation is not the act, the *performance* of Monsieur Marcel Duchamp dropping his thread. What is important is the *projection* of this thread thanks to the motor energy of its weight and to the apparatus of transformation, which is chance. Projection as *transformance* . . .

There is a photograph of Marcel Duchamp as a woman. Monsieur Marcel projects himself into Mademoiselle Rrose Sélavy. The problem is not that of putting on drag. It is this: By means of what energy and of what transformative

apparatuses (for channeling or redistributing energy) can a man's face be projected as a woman's face, or vice versa? Consider the two figures of one and the same object N (= neuter, the name *Duchamp*) projected into two spaces, the masculine and the feminine. Here the accent is placed on the similitude of the two figures, not on their incongruence. But it's their similitude that is incongruent with regard to the belief in the difference of the sexes. In the same way, two similar volumes that are symmetrical in relation to a plane, for example the glove of the right hand and the glove of the left hand, are not superimposable: the one won't go into the other. Here the accent is placed on their incongruence, but it's still a problem of projection, and it's still their (mathematical) incongruence that is incongruent with regard to the prejudice of the perfect symmetry of vertebrates.

Concerning language, Duchamp seeks the same effects of transformation by projection. They can be obtained at the different levels of language. One example only: "If you want a rule of grammar: the verb agrees consonantly with the subject: For example: *le nègre aigrit, les négresses*

s'aigrissent ou maigrissent." (DDS, 159)[1] The grammatical rules are those of declension for the noun and of conjugation for the verb. These two systems of marking are at least partially independent. Here, Duchamp proposes to mark them by one rule, whose principle he borrows from Jean-Pierre Brisset, and that consists in a simply phonic derivation (declension). The two independent systems are made similar by the projection onto them of one and the same rule.

We know from the White Box that the "plastic" problematic of the *Large Glass* is that of projections. The lower region, the Bachelor region, is treated according to the procedures of Italian perspective: three-dimensional objects are projected onto a two-dimensional surface by means of the *costruzione legittima*: symmetrical viewpoint and vanishing point, orthogonal lines of the transfer to the square; distance-point, diagonal lines of construction. The effect produced is in principle that of the virtual three-dimensional, that of deep space dug out in the sup-

[1] The negro embitters, the negress turns sour or gets thinner.

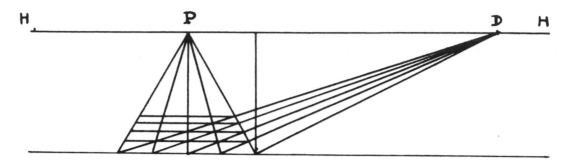

Costruzione legittima after Leonardo da Vinci (from J. Baltrušaitis, *Anamorphoses,* Flammarion, 1984).

H ↔ H Line of Horizon P Principal Point D Point of Distance

port by perspective. But as the support is made of transparent glass, the eye paradoxically *cannot* traverse it to explore the virtual space. When it traverses it, it encounters the "real" objects that are behind the *Glass,* for example the window of the exhibition room of the Philadelphia Museum. It is thrown back onto its own activity, without being able to lose itself in virtual objects, as the reality-effect would have it. A transformation of the perspectivist transformation.

The *Glass* is made of two regions separated by bars of glass, the lower one being the region of the Bachelors, and the upper one the region of the Bride. The transversal lines that separate them are like the hinge (*the* hinges) of a mirror with two or three faces. The two virtual spaces of the

top and the bottom are in a relation of incongruence one with the other like the two gloves. Bride and Bachelors occupy similar and non-superimposable spaces, unless you bring in a meta-operator (which would be four-dimensional). (In reality the situation is a little more complicated: the figures of the top, pieces of the Bride, are not the projections of a three-dimensional object onto a plane, but the two-dimensional projections of the three-dimensional projections of a four-dimensional object; the meta-operator would have to be five-dimensional.)

The relation between the *Large Glass* and the last work, *Given,* is itself a projection or a group of projections, which passes all the elements of the *Glass* into those of the last Nude. Each element undergoes a singular transformation. We ought to be able to find the transforming apparatus, which must be very complex. I will briefly say that you pass from an ascetic and critical plastic formulation, that of the *Glass,* to a popular, pornographic, pagan formulation, that of *Given,* but both of them are formulations of one and the same object. This object is still a *name* (Duchamp is a nominalist), the name of the woman laid bare.

This name is itself a hinge or a projection operating between two times. The expression "The Bride laid bare . . ." is equivocal: is the woman *already* naked, or *not yet*? The stripping-naked by itself lasts but an instant (that of the "blossoming" of the woman, as Duchamp writes), which is projected according to two incongruent but symmetrical temporalities in the two great works: the time of the *Large Glass* is that of a stripping naked *not yet* done; the time of *Given* is that of a stripping naked *already done*. The *Glass* is the "delay" of the nude; *Given* is its advance. It's too soon to see the woman laying herself bare on the *Glass,* and it's too late on the stage of *Given.*

The *performer* (?) is a complex *transformer,* a battery of metamorphosis machines. There is no art, because there are no objects. There are only transformations, redistributions of energy. The world is a multiplicity of apparatuses that transform units of energy into one another. Duchamp the transformer does not want to repeat the same effects. That is why he must be many of these apparatuses, and must metamorphose himself continually. He wants to win

first prize every time, in all the competitions, for new patents.

Duchamp as several transformers. *

17 November 1976

* In English in the original.

Partitions

A first version of this text was published under a different title in the catalogue of the exhibition "The Bachelor Machines" organized by H. Szeemann and presented for the first time in Berne in July 1975. This catalogue, entitled Junggesellen Maschinen / Les Machines céli- bataires *and first published in a bilingual German-French version fol- lowed by another in English and Italian, was directed by Jean Clair and Harold Szeemann. It was published in Venice in 1975 by Alfieri Edizioni and H. Szeemann.*

"Goodbye! Indeed, we shall meet again.
On one condition: let's get divorced."
Nietzsche (to Strindberg)

Machinations

Franz Reuleaux defines the machine as "a combination of
resisting bodies, assembled in such a way that, by means
of them and certain determinant motions, the mechanical
forces of nature are obliged to do the work." The mecha-
nism of machines is insisted upon; thus Canguilhem:
"assemblage of deformable parts with periodic restoration
of the same relations between parts"; Reuleaux suggests
another direction: this same mechanism is a *trap* set for
the forces of nature.

The interesting thing is not primarily that it perpetuates
itself through use, restoring its identity from one produc-
tive cycle to another and thus determining a certain tem-
porality; but that it is a trap, an apparatus that lets us

overturn relations of force. The machine is then neither an instrument nor a weapon, but an artifice, which is and which is not coupled with nature: it is so coupled in that it does not work without capturing and exploiting natural forces; it is not so coupled in that it plays *a trick* on these forces, being itself less strong than they are, and making real this monstrosity: that the less strong should be stronger than what is stronger.

With the idea of the Bachelor machines there is a blossoming out, in full daylight, of this unconscious of cunning implied in the invention of mechanisms that modern and contemporary technical thinking has silenced in favor of dominating and possessing nature. The *mèchanè* of the ancient Greeks is at once machination. Nothing but that.

In mechanics, "the smaller dominates the larger," says Aristotle. This is *atopon* and *thaumasion*: having no place, and giving surprise. The reversal of forces opens a pathway through the impasse of a relation of forces that is unfavorable to man and favorable to nature. A trap that cannot be used twice. Machination opens up a capricious temporality, made of opportunities, discontinuous and ephemeral ones, a temporality that the Greeks named

kairos, the right moment, the favorable instant. The opportunist machine is necessarily a soft machine.

Bibliography: Lewis Mumford, *Technology and Civilization,* 1934. Franz Reuleaux, *Kinematics. Fundamental Principles of a General Theory of Machines.* Georges Canguilhem, "Machine et organisme," in *La connaissance et la vie,* 1952.

Retortions

Machination reverses the direction, and hence the impact, of forces. Aristotle gives as an example the movement of a circle and, in principle, the movement of any *mèchanè.* The extremity A of the diameter of a moving circle moves in a direction opposite to that of the other extremity B: point B goes up when point A is going down. The point A′ of a circle at a tangent to the first one at point B will be pulled in the same direction as B, hence in the reverse direction to A. This circle transmits the movement that animates it, but reverses its direction. The tangential point is a limit point, where the movement is twisted back. The circumference of the circle, the site of these points, is a *limes* of inversion of the movement.

The body of the trap contains this *limes* in itself: It has the power to turn itself inside out, inverting its exterior and its interior. In the Hellenic tradition the fox turns his body inside out when the eagle dives on him; or the octopus, "which unfurls its internal organs, turning them outwards, stripping off its body like a shirt"; or Hermes who, having stolen the cows of his brother Apollo, confuses the tracks by making the herd walk backwards.

Today the category of these non-reliable bodies, capable of such twists and turns, includes the gloved hand of Roberte as sketched by the "semiotics" of Pierre Klossowski: For it's just when the aspirant, using his strength, ungloves this hand in the hope of taking possession of the flesh itself that the latter escapes, because the appearance of the epidermis metamorphoses him, the predator, into a prey. Likewise, Ovid's Diana, pursued by Actaeon while she is bathing naked, changes him into a stag and has him hunted down by her hounds.

These bodies with an integral energy-inverter are Bachelor-machines; their celibacy is only another name for their cunning, the celibacy of the wife Roberte as much as of the virgin Diana: It's always when there is contact

between two bodies in movement, the two circles, the hunters and the beasts, the suitors and their lovely objects, and when from one side a claim arises to unite them, to unify them in one body animated by the same movement, hence when the aim of coupling or of composing forces appears, it's then that retortion comes along to foil this claim, erecting the dissimilating partition between the partners.

The first Bachelor machine was Pandora. The "woman" is an automaton constructed by Hephaestos, the magician-blacksmith who makes auto-mobile tripods for the councils of the gods and animated golden statues to act as servants at his house. Hermes for his part, the wily god of change and transition, endowed the android with speech, with "a she-dog's cast of mind" and with "a side-stepping style." Then Zeus takes command of the automaton; he intends to make Prometheus and his beneficiaries, humanity, pay for the theft of fire by proving that his divine power of machination gets the better of the slyness of their hero. Epimetheus, he-who-understands-afterwards, the inverted double of his alter ego the cunning one, he who thinks he's marrying Pandora, is thereby the designated victim of this stratagem, as is the human race after him.

Amèchanos dolos, a trap without a remedy, a trap for which there is no riposte.

You will object that the trick played by the master of Olympus doesn't require a great artifice—the gods are by hypothesis stronger than men. Nevertheless, when it comes to *mèchanè* the former are perhaps better endowed than the latter, but they are still vulnerable: they succumb without resistance to the charms of Love and Sleep; although they escape Death (the non-machinelike trap par excellence), Homer says that they hate Death nonetheless.

No, Zeus's game is not that of an omnipotent: wasn't he, after all, surprised by Prometheus? Doesn't his cunning come in second place? In fact he didn't have the initiative, and Pandora is only a riposte. Machination of men, counter-machination of the gods: like Aristotle's two circles, the one sets the other moving, in the opposite direction. This fable announces simply that men and gods do not form and cannot form a unity together, that they remain celibate with respect to each other. Their tricks, far from suppressing the partition of retortion that separates them, assumes it and confirms it.

Bibliography: Aristotle, *Mēchanica.* Jean-Pierre Vernant, "Remarques sur les formes et les limites de la pensée technique chez les Grecs," in *Mythe et pensée chez les Grecs,* 2d edition, 1965. Marcel Détienne and Jean-Pierre Vernant, *Les ruses de l'intelligence. La mētis des Grecs,* 1974. Laurence Kahn. *Hermès passe, ou les ambiguïtés de la communication,* 1978. Pierre Klossowski, *Les Lois de l'hospitalité,* 1965; *Le Bain de Diane,* 1956.

"Dissoi logoi"

Now we have a "logical" model of the Bachelor machinery. (But is it a model? This thinking by means of models, isn't it the enemy of machination?) It was the Greek Sophists, the Protagorases, the Gorgiases, the Prodicoses, the Antiphons, who assembled it and got it going. To every discourse there must be another opposing it in a rigorously parallel manner, but leading to the opposite conclusion: sophistics is above all the art of making these duplex / duplicitous speeches, *dissoi logoi.* Thus Protagoras teaches how to pronounce praise and blame on the same subject. Thus the *technè* of the rhetor Corax, reported by Aristotle, consists in turning upside down the meaning of verisimilitude: "For example the case of a man who is not

open to accusation: though of feeble constitution, he is accused of physical cruelty; his guilt is implausible. But if he gives the accusation a hold because he is strong, his guilt is no more plausible than before: for it was plausible that they should think him guilty." This procedure arouses Aristotle's indignation: "This is to make the weakest thesis *(logos)* be the strongest. That's why people were right to get angry with what Protagoras was professing; for it's a pure illusion *(pseudos),* apparent and not real plausibility, which does not belong to any art *(technè)* outside of rhetoric and eristics."

This condemnation is the central business: the man of knowledge claims to put an end to sophistics in the name of the true, of an art—or science—of what is really plausible. Here begins the terror, i.e., discourses and actions governed by the desire to have the last word, accompanied by conviction. In place of the refined and apathic prudence of dissimilated discourses comes the gross pretension to a unique and total theory. Sophistics requires a space-time of speech and of society, especially political speech and society, where the terror of the True or the False has no place, where one has no need of these criteria to justify what one says and does, where one judges things only by their effects.

The man of knowledge says everything about his pretensions to unify the discourses in a couple or a process of coupling that he declares to be superior (that of dialogue, in Plato; dialectic, in Aristotle), when he thinks he is refuting the art of antilogies by saying that, if you want to come to a conclusion, you have to apply a common measure to the reasons for and against, and a judge to define and apply it. No better judge, thinks Plato, than the ensemble formed by the interlocutors themselves, on condition that they seek to convince, not to defeat, each other. There is the adversary of Bachelor machination, conviction, another word for the concubinage of dissimilars. The State, the State of the philosophers obviously, comes along to set itself up as the synthesis of the antilogies. Thus are the positions taken by the adversaries in the Great War in which we are still involved and in which we have to choose which camp to be in, as did Kafka, Jarry, Duchamp and Nietzsche: the Sophists against the Philosophers, the dissimilators against the assimilators, the "artists" against the reasoners, the Bachelor machines against industrial mechanics, the partisans of the partition-wall against those who claim to suppress it (*Aufhebung*). What the *mèchanè* aims to disorganize and, if possible, to foil, is any totalizing and unifying machine, whether in the area of technology (in the contemporary

meaning of the word) or of language or of politics. Thus it is that the cunning ones can bear the names of their enemies: "A new race of philosophers is coming up over the horizon: I [Nietzsche] make so bold as to baptise them with a name which is not without danger, such as I anticipate them, such as they let themselves be anticipated. . . . These philosophers of the future would like to have the right, perhaps also the wrong, of being called tempters. . . . Assuming that the truth is a woman, haven't we got good grounds to suspect that all the philosophers, inasmuch as they were dogmatic, did not understand very much about women? . . . And certainly she has not let herself be seduced."

Bibliography: Aristotle, *Rhetoric.* Jacqueline de Romilly, *Histoire et raison chez Thucydide,* 1956. Mario Untersteiner, *I Sofisti,* 1967. Friedrich Nietzsche, *Beyond Good and Evil,* 1886.

Incongruences

"We like to look at the world [say the tempters] with all sorts of eyes, and also with Sphinx's eyes; that when viewed sideways a thing takes on quite a different look

from what you could have supposed it would as long as you were looking at it from the front. It's one of the nice surprises for the love of which it's worth the trouble of being a philosopher."

The machine that appears to be the most faithful one, the mimetic or reproductive machine par excellence, is the partition of reflecting or recording glass: What injustice has been done to it by the optics and the geometry of the dogmatics, to it, the machine that keeps hidden in its two-faced slenderness no fewer machinations and retortions than the two circles of Aristotle in their simplicity and no less seductive obliqueness than is demanded by the gaze, or view, of the new "philosophers"!

The partition wall of a mirror is a machine fed by the objects that are presented to it and that produces other objects, the images that it reflects. The "looker" is the user of this machine. Now the product differs from the presented object in two properties: its apparent distance, except for exceptions, and its position.

As for its position, Kant shows that the plane mirror, or more generally the symmetry with regard to a plane in

tri-dimensional space (or with regard to a straight line in bi-dimensional space), though it guarantees well the similitude of the two objects, charges them with a curious property, which he names their incongruence; thus the right hand can be similar and symmetrical to the left in all its points, but they are nonetheless non-superimposable on each other: it's impossible to put a right glove on a left hand. The same goes for the two halves of a human body, even if they were perfectly similar.

But, adds the philosopher, it is enough to apply a mirror along the vertical axis of this body in order to make the half presented to the mirror produce, in the form of its reflected image, an appendage that is fully congruent (superimposable) on the other half. If the specular image of the right hand is a left hand, the image of this image is a right hand. Such is therefore the singularity of specular machines, that by assembling two of them in series you can annul the difference of position of the effects: thus you will have a succession of specular products of which each will be incongruent or congruent with the model according to whether it comes in an even or odd rank, respectively, in the series.

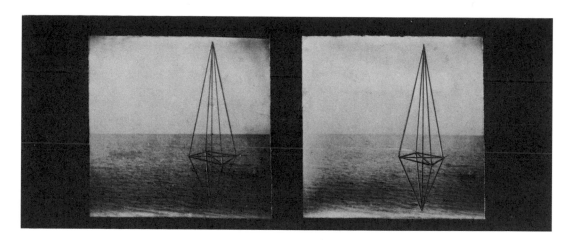

Marcel Duchamp
Handmade Stereopticon Slide (New York, ca. 1918–19).
Cut-and-pasted stereopticon slide, and pencil on black paper surfaced cardboard,
$2^5/_8$ x $6^3/_4$" (6.8 x 17.2 cm).
Collection, The Museum of Modern Art, New York. Katherine S. Dreier Bequest.

The specular machine is, with regard to the position of its effects, identifying when it is itself doubled (raised to an even power), but dissimilating when it functions alone or when assembled with itself in uneven quantities. You will observe that the first-named function, which we will call assimilating or specular, puts three objects in play: the object presented to the first mirror, its image in the latter, and the image of this image in the second mirror; for the dissimilating function to be exercised, on the contrary, the first two are sufficient: it is this latter function that Duchamp calls *mirrorish*.

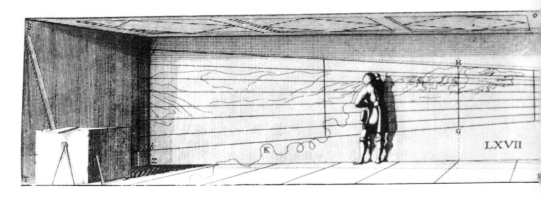

J.-F. Nicéron
Engraving showing the anamorphic rendering for a wall painting.

The nature of the final product of the series of mirrors depends on a decision about the number, odd or even, of the mirrors. Such is the "solution" that the Socrates of Plato, and later Hegel, proposes for the *dissoi logoi* of the Sophists: the double discourses keep us in a state of incongruence, so we must, says the philosopher, find thirds for them in order to arrive at the unity of contrary theses. You could say the same about circles in motion: a third circle at a tangent to the second will turn in the same direction as the first. The partitions, which are the tangential contacts, are thus two in number: the couple of the specular function and the celibacy of the mirrorish function.

Bibliography: Immanuel Kant, *Of the First Foundation of the Difference of Regions in Space* (1768).

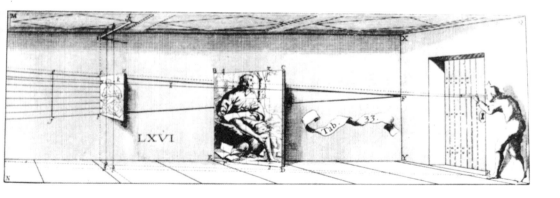

Anamorphoses

A transparent pane of glass can be used as a mirror.
Leonardo suggests this to painters, in his *Notebooks:* The
object, seen through the pane, is drawn on the glass sur-
face. The drawing is then transferred to an opaque sup-
port, set upright like the glass. Now, the two images are
congruent superimpositions. However, if you now rotate
the pane around a vertical axis and trace the image on the
opaque support, the images will not be superimposable.
This rotation is the analogue of the mirrorish operation.
As you see, the partition functions in two ways: to dissimi-
late and to assimilate.

The practitioners of perspective refine the specular, or
"identitory," function. The machines engraved by

Dürer—intended to guide the drawing of portraits, still lifes, and nudes—are "organs" that work parallel to *Vergleichung,* or identification. They are machines that regulate what we see and what we transcribe for seeing. Above all, the apparatuses must be able to determine "visual" distance. To accomplish this, the machines employ chinstraps, eyecups, sheaths, visors, and lattices. Given all this paraphernalia, it's not surprising that the product (image) appears congruent with the model.

On these "grids" you see better what is demanded by the assimilatory functioning of the limit partitions: The only thing that can be noted down, carried over, and replicated is the object that has been fixed and riveted by the scopic machine in conformity not with the object but with the principles of reproduction according to which the machine was built, which are those of a simplified Euclidean geometry.

And yet the seekers of anamorphoses, such as Nicéron and Maignan, made Dürer's grid work "in reverse" to produce dissimilation: instead of projecting the "real" object on the movable panel of the grid, they fix on this panel the image of this object projected onto a plane that is not par-

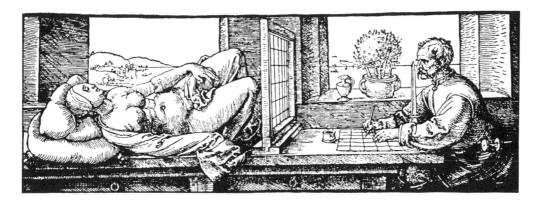

A. Dürer
(Nüremberg, 1525).

allel but oblique to that of the grid. And instead of plac-
ing the straight lines of flight and distance in planes that
are orthogonal to each other, they bring them close so as
nearly to confuse them.

Here the machine dissimilates openly. The shift of posi-
tion between what goes into it and what comes out of it
makes the product open to misrecognition. (Of course it
would be enough here to add to the first a second ana-
morphic apparatus functioning in reverse to restore the
original in its identity.) The trick consists in the way the
determination of the points and lines that govern the
operation is not less meticulous than in the "legitimate
construction" in the way the spectator's body is no less
corseted, but in order to obtain an opposite effect.

Bibliography: Leonardo da Vinci, *Notebooks* (1508). Jurgis Baltrusaitis, *Anamorphoses, ou magie artificielle des effets merveilleux,* 1969.

Hinges

"The continuum with n dimensions is essentially the mirror of the continuum with 3 dimensions." Duchamp's *Large Glass* is a modern anamorphic machine, including in itself the possibilities of new cunning and of improbable celibacy given by non-Euclidean geometries. It's no longer only a question of incongruence between figures, but between spaces.

The *Large Glass* is traversed in the middle by a duplex partition analogous to the one that separates the *dissoi logoi* of the Sophists. This partition is not visible to the eye adapted to tri-dimensional space, except as a line: "It is certain that any point of space3 masks, hides, and is the end-point of a line of extension. One would like to turn around this point and perceive this 4th direction which arrives (at this point) in contact with space3—likewise a

line of a space³ masks a plane; it's like the one and only slice of this plane to be visible to the eye³." (DDS, 135)

The line that separates the top and the bottom of the *Large Glass* would be the "slice" of a plane. This plane represents the hinge between two tri-dimensional virtual spaces, that of the Bachelors and that of the Bride: in the 3-dim space, the intersection of two volumes is a plane; but in bi-dimensional space, as constituted by the surface of the *Large Glass* and likewise by any picture, this plane is projected under the appearance of a line, the one that separates the top and bottom regions.

The *Glass* would thus be a mirror with two faces, having as its hinge the line that crosses it in the middle: this is how it presents itself in bi-dimensional space. But each of the faces opens on a virtual tri-dimensional space: a perspectivist cube enclosing the Bachelor mechanisms down below, and a more complex, freer (but still tri-dimensional) space above, where the *Pendu femelle* and the Milky Way are suspended. These two faces look at each other, or at least did look at each other, before being brought, by rotation, around the hinge in the middle, onto one and the same

plane, that of the *Glass.* The two virtual spaces thus reflect each other (they are married), but are strongly incongruent (they are celibate).

So strong is their incongruence that it cannot be suppressed by an operation of replication like the one that Kant suggests as a way of making the two halves of a human body superimposable. Or rather, one can conceive of this operation but not see its effects. For the removal of an incongruence between volumes would require that you have at your disposal a fourth dimension, one that might be suggested by a tri-dimensional mirror, for instance, a mirror with three faces that all reflect one another. And the *Glass* is also this, with its three transverse lines. This configuration does not mean that Bride and Bachelors, the two parts of the work, are separated forever, nor that they can be united in a virtual space. There is between them the same partition wall that conjoins and disjoins antithetical discourses.

Just as there is no third instance to make sensible syntheses out of the sophistic *logoi,* there is no fourth dimension to make the Bachelor volumes superimpose themselves visibly on the married volumes. But as it is just to defend both theses and wise to let yourself be equally persuaded by

them both, so it is *sensible** to trap the quadri-dimensional with something bi-dimensional and to present as composed together that which refuses composition.

> *Bibliography:* Marcel Duchamp (Arturo Schwarz edition), *Notes and Projects for the Large Glass,* 1969. Sanouillet and Peterson, editors, *Duchamp du signe,* 1975.

Tortures

Cora loves a woman F.B., who is prostituted by a man with no name, "the one who received." He obliged F.B. at first to piss in the toilet bowl in the presence of Cora. Later, in the toilets of the brothel, he asked Cora "to hold, over her face, the pane of glass held out to her." He ordered F.B. to piss and shit on this pane. "Cora thought that they would not stop her from loving F.B. because of that, because of them."

Such is the cunning of dissimilation in the face of *terror,* of assimilation, that wants to get congruence and to transform the mirrorish into the specular: "While F.B. was

*in English in the original.

washing, He who received asked Cora to use, in her turn, the pane of glass over the face of F.B." To make the two women, all women, superimposable, is what both the pimp and the philosopher-politician demand, whereas the singular love of the one for the other makes them, precisely, non-convertible.

Cora refuses, she gets beaten, she ends up being put on the pane of glass, but instead of F.B., it's a client who takes up his position under it. Once again the transparent pane has acted as a celibacy machine: holding apart those who looked at each other in it. And it's the same pane that counts for the lover and for the Great Duplicator, but in a different way.

All the questions of power and non-power, whatever name they bear, stem from the functioning of this partition. The trick is to use the specular and the reproductive, those mechanisms of assimilatory terror, to engender something dissimilar, to invent singularities.

Bibliography: Xavière, *F.B.,* 1970.

February 1975

Machinations

This text formed the basis of a paper presented at the Maison Française at Columbia University in New York in November 1974.

Dissimilating mechanics

To interpret is futile. You might as well try to circumscribe the true effect of the *Large Glass* and hence its true content; the *Glass* is made precisely in order not to have a true effect, nor even several true effects, according to a mono-, or polyvalent logic, but to have uncontrolled effects; the true is only the controllable, like the false, whereas Duchamp is aiming for a space beyond truth-values: inability and power.

Any interpretation comes along and hollows out its object from the inside, comes along and substitutes what the object is supposed to hide for what it's assumed to manifest. Thus interpretation feeds on nihilism, and feeds nihilism. But when Duchamp says: my Bride is a projection onto a plane surface of a tri-dimensional Bride, who, in turn, is the projection of a quadri-dimensional Bride, far from suggesting a construction *en abyme,* an abyss of signs each effacing itself before the next, he opens, on the contrary, a group of spaces where all these Brides, and others, will be present, whether visually or not: spaces

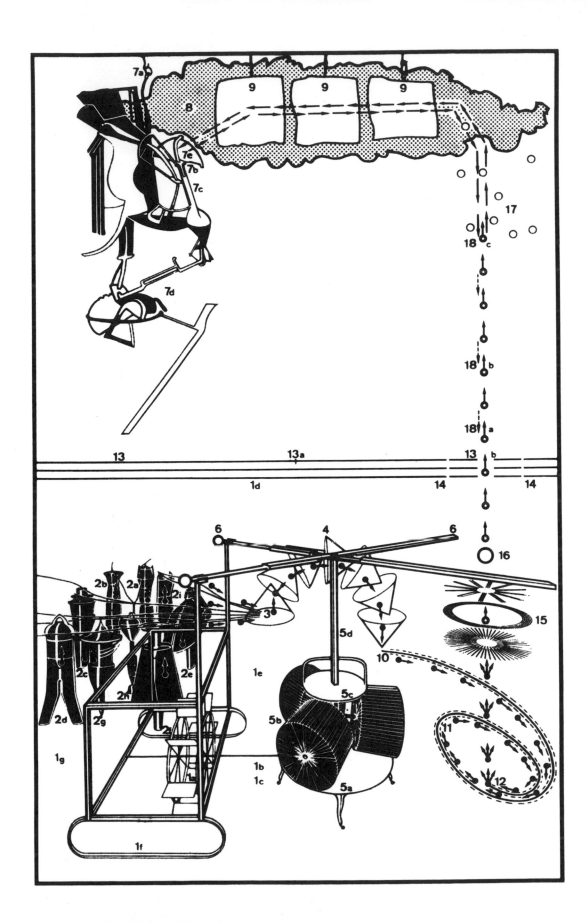

Sketch of the workings of the machines in the *Large Glass*

1 Trolley
1a Watermill
1b Pinion
1c Trapdoor opening to the basement
1d Rocker Pulley
1e Revolution of the bottle of Benedictine
1f Skids of the sledge
1g Luggage-strap
2 Cemetery of the uniforms and liveries, or Eros Matrix
2a Priest
2b Department store supplier
2c Policeman
2d Cavalryman
2e Officer of the law
2f Undertaker
2g Lackey
2h Coffee-waiter
2i Station-master
3 Capillary tubes
4 Sieves
5 Chocolate-grinder
5a Nickel-plated Louis XV tripod
5b Rollers
5c Necktie (sling)
5d Bayonet
6 Large scissors

7 Bride
7a Suspension-ring of the *Pendu femelle*
7b Ball-and-socket mortise
7c Shaft bearing the filament-material
7d Wasp (??)
8 Milky Way flesh
9 Draft Pistons
10 Ventilator-churn
11 Flow-slopes or surfaces
12 Splashings
13 Horizon-clothing of the Bride
14 Battering-rams
15 Occular Witness
16 Kodak magnifying-glass lens
17 9 fired shots
18 Gravity-handler
18a Tripod
18b Shank
18c Ball or stabilizer
▪➤ Journey of illuminating gas
➤ Bride's language

(Taken from *Miroir de la Mariée*, Jean Suquet (ed. Flammarion).

of dissimilating metamorphoses. That is why he "talks machine" and "paints machine": the important thing being that figures of forces should be transformed strangely.

Duchamp's position is affirmative. He situates it himself as "ironism of affirmation." Shall we pretend that all irony implies negation? But the affirmation in question does not exclude negation as if it were its opposite; if the affirmation is ironical, it's because it includes separation, distance, regret, and jealousy: and all these things must be thought of affirmatively, as potencies. In this direction, Spinoza would be a good guide if he was not himself also the victim of the nihilist hierarchization of passions and knowledge; but let us imagine sadnesses that are no less potent, opened out, and zealous than happinesses are. Duchamp likes machines because they have no taste and no feelings. He likes them for their anonymity, which keeps nothing and capitalizes on nothing of the forces that they articulate and transform, and suppresses the question of the author and of authority; and he likes them because they do not repeat themselves, an even stranger thing for minds penetrated by the equation: mechanics = replication. No assimilation in the causes and none in the effects.

His mechanics is dissimilating; it does not belong to the things of power, to politicians, to technicians. It's the mechanics of machination. Its effects are not recognizable and thus consumable beings, but singular, misrecognizable inventions, which presuppose the exercise of a faculty of cunning. This cunning does not accumulate its results. It is not the gross cunning of reason, whose dialectical tricks would be sniffed out and foiled by a puppy, so conscientiously do they repeat themselves and that define, as we know, not a labyrinth, but an empire (that of capital, latterly). The cunning machines are not productive; they are not established. If we could call them celibate, it's certainly not because you have to have lost God and his law to conceive them, to use them, and even to make them for yourself; rather, it's in homage to their pointlessness. And let us remember that Duchamp's machines are not only bachelors, but also married.

Dischronic logic

"There are no problems, problems are inventions of the mind," declares Duchamp to Rudi Blesh. The machineries or inventions that are hatched in Duchamp's "brainishnesses" are not answers to these questions. The answers

are the deed of the power-machines: How to allow a client who has both hands full to open a supermarket door? A photo-electric cell. How to allow an airplane of n tons to take off? Acceleration feedback to the engines. How to control opinion when the political parties are boring? Television. How to found, that is, to authorize, the scientificity of a discourse? Divine veracity; a priori universality.

Duchamp's machines are not enslaved-assertive but spontaneous-affirmative: they know no consequence. This property becomes evident *a contrario* in Duchamp's language under the exterior of implication: "Given: 1 the waterfall, 2 the illuminating [lamplight] gas . . ." (DDS, 43)[1] whose future we know about; or one of the

[1] In this part of the text, the notes are quoted from the facsimile edition established by Arturo Schwarz, *Notes and Project for the* Large Glass, Abrams, New York, 1969. For the convenience of the reader, we have restored the references to the French edition of Sanouillet, noted as DDS. The reader will notice some divergences in the readings. The sign / indicates a new line in the manuscript; the sign / / indicates a new line with a paragraph marker; italics indicate what is emphasized in the manuscript.

rare pseudo-confessions in the Notes: "given that . . . if I assume that I am suffering much . . ." (DDS, 36); or the Idea of fabrication (ibid.): "If a straight horizontal thread one metre long falls / from a height of one metre on to a horizontal plane, / deforming itself *at its own free will* and gives / a new figure of the unit of length," which goes on: "—3 copies obtained in conditions / that are almost similiar / : in *their consideration each for each* / are an *approximate reconstitution* of the unit of length. / / The *3 standard stoppages* are the diminished metre."

The implication is incomplete; the implied statement is missing. Even the proposition "3 copies" does not result from the hypothesis "if a straight horizontal thread"; it's a tautology. A formally correct implication would be "If a horizontal straight thread (etc.), deforming itself at its own free will, *it* gives a new figure (etc.)." Is this a logical flaw? Rather a little machinery of language that consists in positing a state of fact as if you were going to draw some consequences from it, and then not drawing them. If that's how things are, it's because the effects of this state are not determinable on the basis of the act of positing it. The power-to-do consists entirely of a potency that controls its effects; implication is the logical equivalent of this con-

trol. For positional potency to contain no operator of implication, the effects when produced will not only appear to be without cause, denuded of reason, but they will strictly be so.

The *if . . . then* of implication leads us to tie together different moments, that of the hypothesis and that of the proposition that follows from it: it makes for a homogeneous time that is required by causality or any other category of this type. But when Duchamp writes "given . . ." just like that (like a child starting to muse about the formulation of a problem concerning the volume of water in a container, a problem that he won't be able to solve and that plunges him into astonishment and boredom, one October evening), the statement is placed in an instant that is itself its own temporal referential; and any statement that you think you can draw from it, far from following from it, must be taken as an autonomous temporal kernel, as the instance of a potency that gives room to a different temporality. Thus you have no succession or simultaneity, but rather autochronies, which have no relations between them other than chance ones, let us say: relations of dischrony. Nothing of the one passes into the other. Each one begins a "story," which is instantaneous.

None of them answers to or for any other of them; none of them resolves a problem. This would always, then, be an abuse of power because it would be a constraint of the one upon the other.

Unoptical vision

The decomposition of movement in the *Sad Young Man* or the *Nude Descending a Staircase* arises from the same desire to dischronograph time. "My goal was," says Duchamp to Sweeney, "a static representation of movement—a static composition indicating the various positions taken by a form in movement—without seeking to produce any cinematic effect by means of painting."[2] But in the works of 1911–1912, the disjointing is represented as affecting the "character" in a kind of exfoliation; and thereby (this was in the long run the fate of the time-lapse photographs of Marey and Muybridge), the eye is authorized, even pushed to resynthesize the arrested movement, to see each of the forms as one of the sketches of an assumed unity, namely,

[2] Interview by J.J. Sweeney, in "Eleven Europeans in America," *The Museum of Modern Art Bulletin* XII, 4–5 (1946), 20.

continuous movement. The representation, with its own—phenomenological—force of synchronization of the diverse, thus thwarts dischrony. In the course of 1912, the *passing* is displaced. It is no longer represented, but sought for in the relation of the eye to the support; and it is reversed, leading henceforth to the multiple. The *Large Glass* escapes the effects of control and synthesis.

Let us take colorings, which are the heart of the matter if it is true that to paint is, at a minimum, to deposit pigments on surfaces. You must foil the chromatic implication, the harmonic transitions from one band to another of the painted surface; you must molecularize each color, render it independent of a unique and uniform light source: ". . . colors taken in the sense of light sources that give color and not as differentiations within a uniform light (sunlight, artificial light, etc.)." (DDS, 117–118) Thus the eye's recourse to the chromatic spectrum is set aside, retarded:

> Assuming several light-source
> colors (of this order)
> exposed at the same time the optical
> relation of these different coloring

sources is no longer of the same order
as the comparison of a red spot and a
blue spot in a solar light.
—There is a certain inopticity, a certain
cold consideration, since these colorants
affect only
imaginary eyes in this
exposure. . . .

(DDS, 118)

An eye without memory. To take the side of position
against supposition, opposition, and composition requires
amnesia:

To lose the *possibility* of recognizing (of identifying)
2 *similar things.*
2 colors, 2 laces
2 hats, 2 forms of any kind
to arrive at the Impossibility of
a *visual* memory sufficient
for transporting
from one similar thing to the other.

(DDS, 47)

It's a question of dissimilating the givens. The whole machinery is dissimilating. Similitude, like causality and implication, comes from the stupidity of the eye, out of which its power is engendered. Dissimilation foils this power: it puts it in check.

The eye needs to think, to unify, to be intelligent. It loves *the point,* as its opposite number in a mirror that it names the world. The perspectivists flattered this stupidity of the point of convergence; it does not arise from the fact of the representation of figures, but from the unitary order that is imposed on them. Duchamp thunders against "retinal," that is, focused painting, and "olfactive," that is, perceptual painting. "As stupid as a painter": he attacks the stupidity that gives credence to the "body," to the organic machine of reproductive centralism. The work of immobilization and demobilization begun by Cézanne is continued in Duchamp, beyond the phenomenological horizon of the "little sensations," which limited its scope.

The dissolution of visual ensembles does not have the goal of rediscovering a body or an *ego* more originary than the Cartesian body, a "flesh" as Merleau-Ponty said, opening onto a world without any established referential. As there

is no problem, there is no origin, not even an impalpable one. The dissolutions brought about by Duchamp's work are not analyses, but inventions or imaginations. There is no ambition to *restore* the deformities floating within the confines of the field of vision or the curvilinear space or the chiasmatic extension that is assumed to govern them. You have to blind the eye that thinks it sees something; you have to make a painting of blindness that plunges the sufficiency of the eye into rout; you have to "make a sick picture." (DDS, 49)

Regret

This is what's at stake in the *retarding* (DDS, 41) that the *Glass* imposes on our impatience to see. If the *Glass* is invisible, it's not through mystique or pessimism, not because of a defect, but through an excessively imaginative machination. It opens intervals and moments of delay; it decompresses the coordinates of centralism; it demobilizes the army corps that is the body of the eye:

> Against compulsory military service:
> a "distance" of each member,

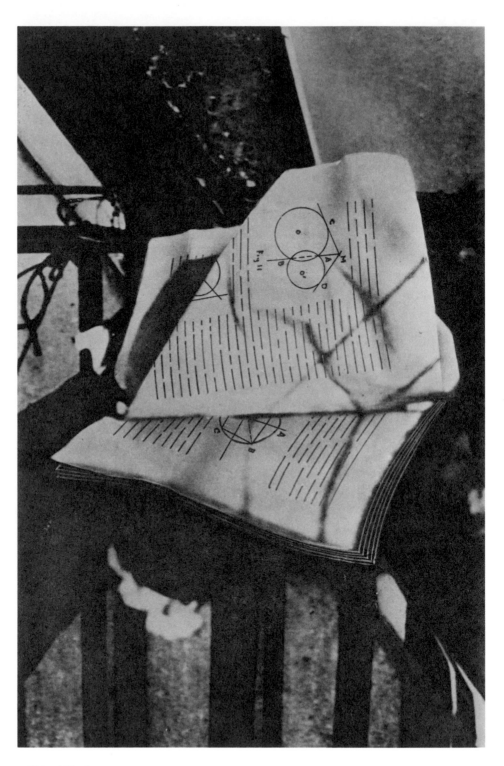

Marcel Duchamp
Unhappy Ready-made
(Buenos Aires, 1919).
Photograph retouched by
Duchamp for the *Boîte en valise.*

from the heart and the other anatomical units;
each soldier being already
no longer able to put on a uniform, his
heart feeding *telephonically*
a distant arm, etc.

 Then, no more feeding; each *"distant unit"*
being isolated.
 In the end a Regulation
of regrets *from one distant unit to another.*

 (DDS, 36)

Not only does uniformity disappear, but so does identity;
not only the assimilation of one soldier to another by an
eye that composes them, but the integration of each
soldier-corpuscle to himself. Once they are undone, the
units cease to have to serve; they are not bodies, but
packets of singularities, packets that come undone in their
turn. It remains to establish between the grains of matter
a "regulation" whose function cannot be to unite them,
but must leave them in regrets: each connection of grain
to grain must be misrecognizable, alien not only to a
different connection between other grains, but to a
"previous" one between the "same" ones.

Regret (jealousy?) is one of the categories of the logic of dissimilation; it designates the connection between unconnected elements. Bachelor link: leitmotiv of the litanies of the Trolley (DDS, 81 and 82), but also the dismetrical formation, by the method of the Standard Stoppages, of the Capillary Tubes that link the male-ish [*mâliques*] Molds with one another. These Molds are "gathered" in a military cemetery, where the abandoned (surrendered) uniforms (or servants' livery) are a matter for regret. This regret is not the nostalgic recurrence of a lost unity, but it is the regulation of occurrence of singularities in dischrony without memory.

Regret is a weak link, which retards something. The difficulty is that it does not appear to retard unification, like the *Glass* itself, but to put a delay into the complete dispersion of the grains: inasmuch as each singularity misses the other, it holds on to it. Isn't that enough to remake a body? Regret would thus be a counter-category in the logic of dissimilation.

But in such a logic, the counter-categories must operate within the categories. Regret is not something that would

suspend the death-bearing fate of an ensemble: this does not exist. It indicates the quality of distancing between the states of the materials and between the regions of the various parts of the machine, a distancing without which the machine would in effect be only an organism. Given planets that would miss the sun. . . . But such a system would be too strong. Let us imagine some dust-specks of matter of the "edge" of a galaxy, missing those that form bodies "on the inside" of this galaxy and the other way around. This link is that of *edge,* of *hinge.* (DDS, 42) Dissimilation would have it that from this "side" and the "other" of a "limit," you would not be dealing with the same space. Duchamp analyzes very thoroughly the dystopic machinery of n-dimensional spaces. Regret is the "cut" in Dedekind's and Poincaré's sense, the failure in the closure of the dimensions.

Chess [in French, *les échecs*—also "failures"] is this game in which Duchamp applies himself not to winning, but to foiling the desire for power, desire to "take," by dissimilating the situation from one move to the next. Thus he plays chess *the other way round.* He makes the apparatus go in reverse, exactly as the anamorphics did with Dürer's

gate:[3] he seeks such-and-such a move of such-and-such a piece, which would have the result that the previous position, having become misrecognizable, cannot but be forgotten, and therefore the sequential *intentions* of the adversary are demolished. Duchamp is neither more nor less a chess player or a painter, but a machine of atomization on all the supports, sifting the time of plans and the space of perspectives, letting the grains trickle away.

[3] What fun to find later in the only edition of the White Box then available (*A l'Infinitif,* trans. Cleve Gray, New York, 1967) the following footnote, which I now transcribe from the original:

> Perspective
>> See Catalogue
> of St G Lib.
> the whole section
> Perspective:
>> Niceron (the Fr Jes. Pr.)
> Thaumaturgus
> opticus

(cf. DDS, 12)

Inexact precision

The heritage of the grains never gathered and put into the barn belongs to Cage, to Feldman. "The same possibility with braininesses [*cervellités*], with sounds." (DDS, 47) Duchamp writes Musical Erratum. (DDS, 52–53) If the *Glass* is an "apparatus / instrument" (DDS, 66), is it because in it is practiced the "rearing of colors" (DDS, 100) and of dust-particles (DDS, 77–78): a machine functioning against the grain of conditioning?

By what sort of cultivation do you obtain grains? Will it be by analysis, going on to ordered decompositions? In time-lapse photography, the method consists in the way the recording intervals are regular; they correspond to the equal distances separating two by two the orifices pierced in the circular plate that turns in front of the objective lens of the recording apparatus. This regulated repetition favors optical synthesis. The same goes for filming and projection in cinematography: the number of images per second of the camera and the projector is constant. These are well-behaved machines, sisters unto each other, daughters of the *costruzione legittima* of Alberti and of Dürer's gate: the

latter a craftsman's tool, the former an engineer's procedure, but both allowing you to produce a volume effect on a plane surface.

These apparatuses are assuredly transformers, whose magical power one can admire, as did the perspectivists; they metamorphose plane figures into volumes and states of rest into movements. They perform seduction (rather than illusion). But you can also (whether or not you start out from an iconophobic tradition: "Rigidity of the Huguenot kind" [DDS, 101]) attack their mimeticism: They can produce only simulacra; their logic is that of replication; their metaphysics that of the recurrence of the same; they repeat represented things, of which the differences among them must never forbid the eye to recognize that they belong to the same optical verisimilitude. So it matters little that these perspective machines can transmute the 2- into the 3-dimensional. This power is nothing compared to the terrible power that condemns them, along with their users, to repeat themselves.

"The idea of repetition terrifies me," said Duchamp in 1958. In 1915: "My methods change constantly. My latest work is radically different from everything that preceded

it."[4] The principle of dissimilation operates not only from one work to another but within each of them. It provides nothing less than the "Manufacture-idea" of the *Glass,* the procedure of the Standard Stoppages: *"approximate reconstitution"* of the unit of length, according to which the Capillary Tubes are designed that conduct the gas coming out of the Molds toward the Sieves. In the upper part, the Draft Pistons are determined according to the same principle:

> 3 Photos of a piece of white cloth—
> *draft piston,* i.e.,
> fabric accepted and refused
> by the current of air.
>
> <div align="right">(DDS, 57)</div>

And again, the nine Fired Shots:

> From more or less far away; at a *target.*
> This target is in sum a *correspondence*
> of the vanishing-point (in perspective).

[4] Quoted by Arturo Schwarz, *The Complete Works of Marcel Duchamp,* New York, 1970, p. 21.

The figure obtained will be the
projection (*of skill*) of the principal
points of a 3-dimensional body—by the
maximum skill, this projection would
be reduced to a point (the target).

By an ordinary skill this
projection will be a demultiplication
of the target. . . .

<div align="right">(DDS, 54)</div>

In general, the figure obtained
is the *seeable* flattening (arrest
while on the way) of the reduced
body. . . .

<div align="right">(DDS, 54)</div>

The dissimilation of, respectively, the units of length,
the squares of cloth, the vanishing point, is the common
"law" or "regulation" that their projection onto the
Glass obeys:

The wind—for the draft pistons
the skill—for the holes
the weight—for the Standard Stoppages
to be developed.

<div align="right">(DDS, 55)</div>

Chance is required as a partner in the game that is played against similitude and verisimilitude; with its help, one can be "precise, but inexact."[5] Precision fights for inaccuracy, defies the inclination of the eye and the mind, which is assimilatory. Bad sciences are exact because they operate according to order and measure, that is, by covering up and by repetition.

Dispective* figure

These observations bring us back to perspective. Is the *Glass* figurative or non-figurative? Neither the one nor the other. It figures the unfigurable; it bears the imprint inscribed, or the shadow cast, on its plane, by a figure that could not be intuited—at least that of a woman having four dimensions, a monster. "Everything that has a tri-

[5] Expression quoted by L. Steefel, "The position of *La Mariée mise à nu par ses célibataires, même* (1915–1923) in the stylistic and iconographic development of the art of Marcel Duchamp," University Microfilms, Ann Arbor, 1960.

*As opposed to "perspective."

dimensional form is the projection into our world of a quadri-dimensional world, and my Bride for example would be a tri-dimensional projection of a quadri-dimensional Bride. Very good. But as it's on a glass, its plane, and so my Bride is the bi-dimensional representation of a tri-dimensional Bride who is herself the projection of the quadri-dimensional Bride into the tri-dimensional world."[6]

All space must here submit to an irreparable retardation. (Irreparable: it's vain, and it's contrary to Duchamp's passion, to his passing, to look for a point of good vision where the *Glass* in its entirety would recover "its" unity, however ephemeral and haloed with the prestige of the erotic.) Duchamp owes it to his stubbornness in favor of dissimilation to take glass, finally, as the raw material for his machine. "To use transparent glass / and the mirror for the *perspective 4*." (DDS, 125) The glass *and the mirror*. Where is the mirror? The *Glass* is itself made by assembling two parts, top and bottom, which are like two mirrors jointed together along a hinge formed by the median

[6] Duchamp to George and Richard Hamilton, quoted by A. Schwarz, *The Complete Works,* 23.

bars of glass. The images we see in these two mirrors, Bachelors down below, Bride up above, are not placed on the same plane; you must imagine that the mirrors form an obtuse angle with each other, and that the virtual spaces that are opened up in them are, let us say: different.

Such is the spatial machination in which we will not take the virtual but dissimilate what is claimed to be the real. To sum up the pages of the White Box that relate to perspective and extension, we obtain the following reasoning, rough, "incorrect," says Duchamp, false indeed, but interesting: you observe that a point does not "cut" the (3-dimensional) volume in which it is situated, whereas a straight line "cuts" it; given, now, a mirror, and a straight line perpendicular to its surface, that straight line "stops" (here Duchamp puts a question mark) at this surface in a point; if you want to have a representation of a quadri-dimensional space, it's enough to imagine that, if prolonged on the other side of the mirror, that straight line presents there the same property as the the point in usual space, i.e., it does not "cut" virtual space[4] any more than the point cuts real space[3]; you can imagine, then, that in prolonging itself infinitely "into" the first-mentioned

space, it is in effect contained there, but without producing any "cutting" effect in it. (DDS, 129) The surface of the mirror operates as a dissimilating mechanism, it metamorphoses the straight line into a point; more precisely, it splits linearity: it extracts a virtual punctuality from the straight line.

On this point (which is not a point) all the work of Duchamp oscillates, and the possibility of representing unpresentable space is played out*; on it stands the whole fiction of the psychic-drive-monster.

Many of the Notes published later under the title *A l'infinitif* [In the Infinitive] turn this operation around and emancipate it from previous errors. You can find there this formula: "The 4-dim. continuous is / *essentially* / the mirror of the 3-dim. continuous."[7] (DDs, 130) There's something with which to refine the problem. How indeed

* "sur ce point . . . se joue la possibilité de représenter l'espace imprésentable" A complex pun: *se jouer* can also mean to deceive, to scoff at, to make light of.

[7] The manuscript has, after "essentially," "a mirror," crossed out.

could the reflection in a mirror endow the determination of a spatial object with an extra dimension, when it has been its recognized property since the optics of Descartes at least, and in fact since the treatises on perspectives that emerged from Euclid's researches—that reflected space is homogeneous to the space that it reflects? Isn't the specular operation *essentially* one that replicates and makes identical?

But Duchamp resorts to the "mirrorish" against the specular, guided by what he knew of the geometers and mathematicians on *n*-dimensional spaces. A duplicating machine, the mirror can be taken as a duplex / duplicitous machine; you can have confidence in the first—it gives back what you give it; the second one is cunning. The cunning is not only the infidelity of the mirror, but also it stems from the fact that its fidelity and its infidelity are produced together, the latter dissimulated in the former. The cunning is itself included in a dissimilation without finality: the straight shelters the crooked and is worked over by it.

This double game of the mirror gives to Kant's elaboration of the "difference of regions in space" its range of force

and uncertainty.[8] At the very moment when there is
revealed "the absolute originary space" that makes non-
superimposable and incongruent ("The body which
is entirely similar to another, if it can be inscribed in
the same limits as the latter, I call it its *incongruentes
Gegenstück*") objects that are nevertheless, from their def-
inition, indiscernible, like two similar screws, one with a
right-hand thread and the other with a left-hand thread,
or two similar spherical triangles, or one's two hands—at
the moment, then, when the originary spatialization is
grasped as a mirrorish power of incongruence of similars,
the specular is summoned also to resolve these contraries,
this time thanks to its power of reduplication. The human
body, if it is made of two halves that are mutually incon-
gruent, it's enough to reflect one of them in a mirror, says
Kant, for its image to become congruent with the other
half; for "the *Gegenstück* (the matching part) of the
Gegenstück of an object is necessarily congruent to the
object, itself." Thus you can fight cunning with cunning,
bring about the manufacture of identicals using an altera-
tion machine. On what function will you decide to stop

[8] *Von dem ersten Grunde des Unterschiedes der Gegenden im Raume,*
Sämmtliche Werke, Leipzig, 1867, Bd. II, p. 390.

the play of cunning and fidelity? Kant stops it on cunning and Hegel on fidelity. Or rather: the question is more Hegelian than Kantian. Kant says: In any case, if there is play and something to be stopped, it's because in the first place you are in dissimilation; the homogeneity of space is a geometer's result.

But what happens if the geometer is possessed by affection for the heterogeneous? If his curiosity goes as far as sizes that are continuous precisely in that they cannot be measured by each other, in that their superimposition is impossible, "in that they are not independent of their position"?[9] Then there develops, starting out from the *Analysis situs*, topology, a geometrical machine functioning "in reverse," not to make commensurable, but to unmeasure. It's this theory of non-measurable sizes that Duchamp encounters in reading Poincaré, who is taken up by Dedekind. It's to this theory that he owes the idea of the "cut," the use of that must permit us, according to Dedekind, to construct n-dimensional spaces beyond the intuitive form imposed on us by perceptible space, the absolute space of Kant.

[9] B. Riemann, quoted by Bourbaki, *Eléments d'histoire des mathématiques*, 1960, p. 147.

Poincaré: "In order to divide space, there must be the breaks which we call surfaces; in order to divide surfaces, there must be the breaks which we call lines; in order to divide lines, there must be the breaks which we call points; you cannot go further and the point cannot be divided, the point is not a continuum; thus, lines, which can be divided by breaks which are not continua, will be one-dimensional continua; surfaces, which can be divided by breaks that are continuous in one dimension, will be two-dimensional continua, and finally space, which can be divided by breaks that are continuous in two dimensions, will be a three-dimensional continuum."[10]

On which Duchamp: an area that can only be cut by 3-dimensional continua will be a continuum in four dimensions. Indeed a space is called tri-dimensional when an element (or line) of a 2-dimensional continuum (or surface) belongs both to this continuum and to a different one: the surface in question is intersected by a line with *any other* surface traced in this space. You would say likewise that a region is quadri-dimensional when an element (or surface) of a 3-dimensional continuum (or volume) belongs both to this continuum and to a different one (to

[10] *La valeur de la science,* Flammarion, n.d. (1905), 74.

a different volume). The cutting power, i.e., the property of a continuum of being necessarily in intersection with all the continua of the same order, is therefore no longer exercised by the surface, but by the volume.

Thus the image of a 4-dimensional angle might be given, thinks Duchamp, by the cutting of two 3-dimensional continua, for example the intersection (at an obtuse angle) of two mirrors, this intersection representing that of two virtual spaces along a "hinge-plane." "For the eye³ in space³, this hinge-plane is only visible at the break with space³, i.e., the line of intersection of the two mirrors. = *The plane*-hinge of the two spaces³ *is hidden behind this* line and the impression is clear for the eye³ which is moving from right to left without ever being able to grasp a little [?] of this plane." (DDS, 131) The angle, a broken line, is thus here the "broken plane" (the hinge) of intersection of two spaces³ in the continuum, and the summit of this angle is a surface. But in the tri-dimensional space of visual perception, this surface will be perceived only as the line common to the two planes of the two-sided mirror. Just as the apex of an angle is an element that belongs indistinguishably to at least two uni-dimensional continua, the two sides of the angle, so likewise the 4-dimensional hinge is an element that belongs to at least

two tri-dimensional continua (the two virtual spaces reflected in the two faces of the mirror).

Metamorphoses of the forms recognizable by means of an operator of dissimilation, that of the Dedekindian "cut": the simple addition of a supplementary "cut" (or dimension) has the effect of disengaging the spatial object from its geometrical identity; it causes to be perceived (but by what faculty?), in the infinity of mirrors that correspond to as many adjuncts to a break, *the series of other objects that this object also is*: "virtuality as a 4th dimension: not Reality under its sensory appearance, but the virtual representation of a volume (analogous to its reflection in a mirror)." (DDS, 140)

The Poincaré-Dedekind explanation seems so good to Duchamp ("Poincaré's explanation about *n*-dimensional continua by the cutting of them by *n-1*-dimensional continua is not in error," [DDS, 138] though it seems mediocre to Bourbaki) that he declares it to be the only one capable of justifying the name of fourth dimension given to the continuum of virtual images. The Dedekindian cut can only be effective there, he says, by means of a

3-dimensional object *considered in its geometrical infinity.*
(DDS, 138)

Irreversible translation

To this virtuality is attached a singular property: any ordinary geometric object is the projection (or the analogue) in space3 of the same object in space4. But many aspects of the 4-dimensional object have no analogue in perceptible space. Here dissimilation resists reversibility. Just imagine this monster: two languages standing in the same relation to each other as these two spaces! One would always be able to "translate" terms or statements from language A into language B, but not the reverse.

In searching for a "dictionary for the written part of the *Glass*," Duchamp envisages several procedures; all of them have a content analogous to that of the addition (or subtraction) of a cut to a spatial continuum.

> To go through a dictionary
> and cross out all the "undesirable" words.
> Perhaps add some others.

Sometimes replace the crossed-out words by
 another one.

(DDS, 110)

Or else:

Make a list of
French proper nouns,
or English ones (or in another language)
or mixed together—
with first-names
(in alphabetical order or
not), etc.

(DDS, 111)

Or:

10 words found by opening the dictionary at
 random at A
. . . ditto . . . at B
These two "sets" of 10 words have the same dif-
 ference of "*personality*" as if the 10 words
 had been written
by A and by B with an intention.

Or else, it matters little; there would be cases
 where this "*personality*"

can disappear in A and in B. That is the best
case and the most difficult.

<div align="right">(DDS, 110)</div>

Or again:

> Take a Larousse dictionary and copy out all the
> so-called "abstract" words, ie
> the ones which have no concrete reference.
>
> Compose a schematic sign indicating each of
> these words (this sign can be composed of the
> standard stoppages).
>
> These signs must be considered to be the
> letters of the new alphabet.

<div align="right">(DDS, 48)</div>

According to a Note (DDS, 10), the making of these signs
might yet be entrusted to photography: one would take
very large shots of parts of large objects; one would make
each of these negatives thus stripped of all face value (fig-
urative or recognizable value) correspond to a group of
words; and out of all these signs one would make a dic-
tionary, "a sort of writing," composed of signs "already
emancipated from the 'baby talk' of all the ordinary lan-

guages." (DDS, 111) Man Ray's photograph, *Dust Breeding,* would be one of these signs. In another Note (DDS, 109), these signs are imagined as "slips of paper" bearing elementary figures "like the point, the line, the circle, etc."

The effects sought after and obtained by these translanguage operations are indicated thus by Duchamp: "Sound of this language, is it speakable? / No." (DDS, 109); "This alphabet suits only the writing of this picture, / most probably." (DDS, 48) That is to say, effects of singularity and retardation in communication, dyslogical effects. They attain perfection in this property: "—of a language which one can translate *in its elements* into known languages but which cannot, reciprocally, express the translation of French words *or others,* or French phrases or *others."* (DDS, 109) It's the same monstrous relation that separates and links, like a regret, the n-dimensional and $n+1$-dimensional spaces: you go from one to the other, and you never completely get back. Thus the *possible*, also called the virtual, is situated "not as the contrary of impossible nor as relative to probable nor as subordinated to plausible," it "is only a *physical 'corrosive'* [of the vitriol type] / burning any aesthetics and callistics."

(DDS, 104) The quadri-dimensional is the force that corrodes visual space, just as writing with macro-semes eats away the chatterbox signs.

In the contact with this different space, with this different language, one cannot but be stupid: invisible figures, unintelligible statements. "An eye^2 will have only a tactile perception of a perspective3. It will have to go walking from one point to another and measure the distances. *It will not have an overall view* like the eye^3. By analogy, the eye^3 has a walking-perception of perspective4." (DDS, 125) The opposite of retinal stupidity is not intelligence; it's this great stupidity of non-power. The intelligence that a Monsieur Teste prides himself on is simply stupidity coming to *have pretensions.* Teste is merely married; a testicle, he thinks he has entirely covered the space of his wife: let us read again the letter of Madame Emilie Teste! The bachelor has intentions, the married man has pretensions: both are stupid in their intelligence. Only the married man / woman-bachelor / spinster attains stupidity, attains walking. *

*Seul le / la marié(e)-célibataire"

Echo of the *wandering-perception* of the quoted Note: "I think it is to be recommended, in order to establish the diverse modalities of the activity of thought, that one does not use at first the relation to consciousness, and that one qualifies *day-dreams* as well as the thought-chains studied by Varendonck (*as freely wandering or fantastic thinking*) by opposition to an intentionally oriented reflection."[11]

Any couple is the coupling of a married space and a Bachelor space by means of a mirrorish glass; the crossing of this glass can be done by changing dimension, irreversibly; this irreversibility is not reversible. The space of passion is made by this coupling. To unify it under the aegis of the theme of castration is an imperialist pretension, and is merely stupid.

Mirrorish Line

Intelligent stupidity cannot imagine that in the other face of the mirror, what it conceives as a line becomes a point

[11] Freud, Preface to the English edition in J. Varendonck, *The Psychology of Day-Dreams,* Allen and Unwin, London, 1927, *Gesammelte Werke,* XIII, p. 440.

also, and that "its" line has no intersecter (not "cutting in reserve" . . .) in the virtual space, any more than a point has in the real. It likewise does not know that "*the principal forms* of the bachelor apparatus or / utensil are *imperfect.* / Rectangle, circle, square, parallelipiped, symmetrical loop; hemisphere." (DDS, 120)

The figures of Euclidean geometry have never ceased to exercise their power of stupid exactitude over our technical, political, plastic, and theoretical imagination for centuries. But if we situate them in relation to the space of infinitization of virtual images, they are only imperfect forms of it; their regularity, like just now that of the spacings in the disc of the time-lapse camera, constitutes their stupidity; it attests to their enslavement to the body of the *mens,* their "measuration." Once unmeasured, the figures of the upper part of the *Glass* would give examples of "principal free (liberated) forms." (DDS, 66–67 and 120)

The *Glass* represents in effect the dispective machine. The space of the lower part, the Bachelor apparatus, is governed by classical perspective. The figures that are placed there can be analyzed for themselves according to a plan and elevation (and this is done by Duchamp himself) (DDS, 60–61); on the *Glass* they are represented according

to their orderliness in relation to a vanishing point, itself placed (as is fitting) on a horizon line formed by the lower edge of the glass rulers separating the two regions.

Now the orthogonals of the Bachelor region that meet up again at this vanishing point (that is, at the edge of the space of the Bride) are in the same position as the line perpendicular to the surface of the mirror, which Duchamp imagines metamorphosed into a point when it is prolonged through the other side of this surface: "To speak incorrectly, the line, seeming to stop at the plane of the mirror, ought simply to traverse it and continue to infinity in its 3-dim continuum; It would not enter the 4-dim continuum; it would contain it without being cut by it. (As the point is contained in the plane without cutting it.)" (DDS, 129) If they pass to the other side of the horizon, i.e., into the upper region of the *Glass*, the Bachelor orthogonals would be contained there, but would lose one power of cutting; the 3-dimensional eye would not be able to recognize them nor even identify them: a Bachelor eye groping in the labyrinth of the four dimensions. This change of exponential power (this loss of strength) is indicated by the mutation of the nine Molds and Capillary Tubes of the bottom into the nine Fired Shots of the top: volumes and lines in front of points.

The transformation is carefully elaborated in relation to the "Wilson-Lincoln effect" undergone by the elements that pass from the bottom to the top of the *Glass;* this effect combines the Kantian incongruence of the right and left with the Dedekindian virtuality:

> Mirrorish sending-back. Each drop
> will pass the three planes at the horizon
> between the perspective and the geometral of
> two figures which will be
> indicated on these 3 planes by the Wilson-Lincoln
> system (ie,
> similar to the portraits which, when viewed from the
> left, give
> Wilson, and from the right, Lincoln)
> seen from the right the figure will be able to give
> a square, for example,
> head-on, and seen from [the left] it can
> give the same square seen in perspective.

> The mirrorish drops not the drops even
> but their image, pass between these 2 states
> of the same figure (square in this example).
>
> (DDS, 93)

A vacillation of space between two incongruent *positions* or two dimensionalities, dystopia.

The cube in perspective, which structures the Bachelor space according to the most "legitimate" construction, is thus arrested by the horizon of the median bars; Duchamp conceives this limit of arrest as a cooler, a decelerator, a retardant. The adjunction of a supplementary dimension (a cut) makes this line into a sort of transformer, which produces "electricity in breadth." (DDS, 36) Around it, space hesitates about its identity; the whole *Glass* starts to float.

The line is what it seems, when seen from the front by the spectator: a supporting bar separating two parts of a large piece of glass ("appearance").[12] It is also what it would seem to be when seen from below by a Bachelor observer placed in the perspectivist space: a limit to his field of vision (first "apparition"); it is still to be seen (second "apparition") from above, in a plane view, as if the *Glass*

12 "In general the picture is the apparition of an appearance." (DDS, 45)

were lying down at our feet, like the tracing of a "mirror-ish" partition raised between the perspectivist space occupied by the Bachelor apparatus and the "liberated" area where the skeleton of the Bride is balanced.

But it's not yet so simple. Perspectivist and "liberated": Are these just other words to say, respectively, 3- and 4-dimensional space, space of the bottom and space of the top? A formal denial of this hypothesis:

> The *Pendu femelle*
> is the form
> *in ordinary perspective*
> of a *Pendu femelle*
> whose true form
> we might perhaps try to find—
> This comes from the fact that
> any form at all
> is the perspective
> of another form
> according to a certain *vanishing-point*
> and a certain *distance.*
>
> (DDS, 69)

The two parts of the *Glass* both present forms in a tri-dimensional space. But they are strongly incongruent with each other, in a sense that exceed the one that Kant had in view. The forms of the top left (*Pendu femelle*) stem from an organization that is somewhat cubist, tri-dimensional, but "exploded." Above and to the right, we are dealing with an abstract modulation of depth, obtained by a floating (the floating of the squares of gauze in the wind, which gives the silhouette of the Pistons) or by interception (a screen that arrests the projection of the Fired Shots). The unity of the two groups of forms of the top can be sought in a 4-dimensional figure. Down below, the Bachelor objects are constructed according to the legitimate perspective, certainly; but even the latter must be understood as a dispective:

> By perspective (or any other conventional means canons) the lines, the drawing are "forced" and lose the almost of the "still possible"
> —with in addition the irony of having *chosen* the primitive body or object, which *inevitably becomes* according to this perspective (or other convention) the.
>
> (DDS, 55)

"The" what? "The" nothing: it *becomes,* it becomes dissimilar to itself. This is enough for the supposedly legitimate construction to be able to be taken, it too, as a dissimilating operation. An idea that will be put to work in *Given.* A very simple idea: this construction consists in treating the (bi-dimensional) plane support of the picture as a tri-dimensional volume, or the volume of the object as if it was flat, therefore to add (or retract) one "cut."

"To make a hinge-picture." (DDS, 42) Unlike those lines that you find in the engravings of Escher or the drawings of Steinberg, which are sometimes valid as heights, sometimes as depths, sometimes as widths, depending on the plastic context or the position of the observer, but which remain situated in a homogeneous space, Duchamp's hinge does not articulate the directions of one and the same space. It represents to the eye[3] the "surface" according to which two volumes[3] intersect in 4-dimensional space. Neither limit of a finitude, nor bar of the signifier, nor repression barrier, but surface dissimulated as a line, making a hinge between two incongruent tri-dimensional volumes, whose overlap (whose commensurability), if there is one, could take place only in 4-dimensional space where both have the same exponential power of cuts as

planes in 3-dimensional space. Yet this place, unassign-
able by anybody at all, is not a place for our intuition.

All this goes beyond the chanted refrains on the *specular,*
issuing forth from a logic, an aesthetics, and a politics of
representation that do not manage to vanquish Plato and
the nostalgic *Similitudo* of Augustine. At which point is
it necessary to say this? And how greatly this overturns
the communicating logic of structures and signs! The un-
conscious figured by the *Large Glass* is not spoken as a
language or represented as theater; it is fictioned in
paradoxes.

Beyond sex*

> The last state of this bride
> laid bare prior to the bliss which
> [makes her fall, *scratched out*] would make her
> fall (will make her fall)
> graphically, necessity to express

*In English in the original.

in a completely different way from the
rest of the picture, this blossoming out.

(DDS, 64)

Bliss=decline? How are we to understand this sentence?
As that of a moralist of sexual repression? Of a libertine
interested in power rather than in intensities? Of one of
those philosophers who conceive desire as barred and bliss
impossible? (In favor of the last hypothesis, these words of
the Box of 1914, perhaps: "We have only: as a *female* the
urinal and we live from it." [DDS, 37]) No, bliss [makes]
would make will make the woman fall inasmuch as she
endows it with an identity, that of "her" sex; and thereby
endows the mans with "his."

What do the Bachelors want, these little soldiers erected
by their terrorist gaseous sperm? To suppress the other
space, or rather dissimilation, to impose on the powers
of the monstrous space the *uniform* of the productive-
destructive machines. So women would be only the other
half of men, and men only their "masters," i.e., parts like
them in the megamachine of reproduction. The stupidity
of intelligence is contained in its entirety in this idea of a

reconciliation, of a totalization of the spaces. It understands alterity only as an opposition, and it offers its services for reabsorbing it dialectically. In the male desire to make the woman have pleasure, there is something much worse than vanity: there is assimilation. It's not so much "You will owe me your bliss as well," but rather "We complete and complement each other; you are my propeller shaft, I am your motor; we are a machine tool."

The laying bare of the Bride attests what, exactly? That the feminine-masculine body (not the body *of the* woman, *of the* man) is an ungraspable space; what we thought sexuality was is a principle of dissimilation, and all power seeks to destroy it. Much more: *"even"* this essay cannot but reveal this same principle. *Even* when they prepare themselves to conquer the white space, the flunkeys of the megamachine unveil its dissimilating power.

Mumford says that the megamachine, the great repetitive apparatus, is an invisible machine, because its components are necessarily separated in space.[13] But this separa-

[13] *The Myth of the Machine,* New York, 1966, vol. I, p. 188.

tion is obviously not dissimilating. It's enough for a shared code to exist that would allow all the elements of the machine to translate orders that are in effect controllable, as well as reserves of energy usable for this translation and for carrying them out. All terror is the inscription, on the feminine-masculine body, of this code and of the closely related device for capturing and utilizing energy for the purposes of reproduction.

You can imagine that at the "level" of execution, the supplies of energy that are necessary for it would be hijacked, put off course, turned back, *retarded*: Spartacus, all the rifle butts in the air, anamorphoses, all the dissimilating machines. This is not the aestheticism of deconstruction, negation of the gross dialectic; these are partial drives playing their game without regard for the terrorist *organon*: dissipation. Violence foils terror as singularity foils the totality. It is at play in it, just as the 4-dimensional is at play in the 3-dimensional and foils it. Its non-sense is affirmatively an-and-some invention(s) of exponential power (of "cuts"), which go beyond all mechanical repetition, which "want" events repeated, not *disorder* (which they shun because it is a category of cen-

tralism). The body of passion cannot give itself up to the tasks of carrying out reproduction. It plays tricks and leaves power *amèchanos.*

The whole Duchamp affair goes via women. Shall we say that women are the principle of the a-mechanizing cunning, that they have no soul, and thus they escape the despotic? They would be violence, and so they would be relegated. Their bodies being mechanically reducible, won't they be devoted to reproduction or to pleasure, won't that be their whole morality: either married or prostituted? But even then, shall we add in full dialectical confidence, they do not cease to be powerful in dissipation, because *they are their bodies,* as Klossowski says. The supplements of energy they capture are not assimilated by them. They do not fabricate identity. Terror is not their strong point; they are afraid of it. Women flee like stretches of water. All ruses are those of flight. Women are the principle of disfunctioning. Shall we say that?

But women are also of the masculine "sex." And the terror consists, among other things, if the whole question passes via women, in identifying the principle of disfunctioning with the difference of the sexes. The latter allows us to

localize and then keep aside all cunning *qua* "feminine trait." Against this terror, Monsieur Marcel transvests himself as Mademoiselle Rrose and works the "cuts." Going beyond the importance given to the difference of the sexes, *and hence to their reconciliation,* he goes beyond, *beyond sex.* * "Sex is not the fourth dimension. It is tri-dimensional as much as quadri-dimensional. One can of course express a beyond of sex by transferring it into the fourth dimension. [*There is, however, an expression beyond sex which can be transferred into a fourth dimension.*]* But the fourth dimension is not sex as such. Sex is merely an attribute: it can be transferred to a fourth dimension, but it does not constitute the definition or the status of the fourth dimension. Sex is sex."[14] Sex, the first, the second, the third, etc., is a product of identification, a file card of the desire-police: it is what the *costruzione legittima* makes of the spaces of passion.

October 1974

*In English in the original.

[14] Conversation with Arturo Schwarz, quoted by the latter, in *The Complete Works,* 36, note.

Hinges

Certain parts of this study were published in the catalogue of the Marcel Duchamp retrospective exhibition at the National Centre of Art and Culture in February 1977, under the direction of Pontus Hulten, Jean Clair, and Ulf Linde.

To give always or almost the why of the
 choice between 2 or several solutions
 (by ironic causality).

The ironism of affirmation: differences from the
 negating ironism, depending only
 on the Laugh.

<div align="right">(DDS, 46)</div>

0. *Preamble:* Two or several solutions to what? What's he talking about? About the "plastic" realization of the projects elaborated in the Notes. So it's about the *Glass.* There is causality because you have to give a why of the choice made between several possible realizations. It is ironic because you have to invent, choose the why that you've given. So there is a choice to be made among the whys. The irony consists in the reversal: you affirm the why of the choice (of realizations); you suggest furthermore a choice of this why. To justify the choice is to transform contingency into necessity or permission into obligation; it's to pass from the "it's possible" to the "it's necessary."

Marcel Duchamp
Door, 11, rue Larrey
(Paris, 1927).
Private Collection,
Rome.

To choose the justification (of the choice) is to reintroduce contingency into the enunciation of necessity: "it is possible that it would be necessary"; or permission into that of obligation: "it's permitted than one must." You transform non-sense into sense, and this sense is itself hung from a non-sense.

Yet you're not obliged to "always give" the latter: "almost always" *can* do the job. "Almost always," that's "often," the probable; "always," that's the necessary. Thus the enunciation of meta-non-sense, or the contingency of the law, is itself regulated by an inclusive disjunction: you have to make this enunciation always and / or almost always. In deontic logic, you would say that it is obligatory and / or (merely) permitted: "it is permitted and / or obligatory to declare it to be permitted that one must. . . ." Hinge logic.

Let us dwell, furthermore, on the infinitive "to give." The value of the infinitive can be notional, if one takes it as the most neutral verbal form, the one to which no complementary signification of number, of tense, of modality, has been added, unlike such forms as *he gave, you would have given, that we should give,* etc. So the infinitive is

taken as the zero degree of verb forms. But its value can equally be programmatic: it indicates then an instruction launched anonymously at any possible receiver, an order executable by anyone at all, a general recommendation like "Shake the bottle before using." What's meant by it here?

Two Notes explain this business. One is entitled *"Recipes"*: "to obtain (general form for describing certain parts): / e.g.: one obtains the fired shots by . . . / to obtain . . . take. . . ." (DDS, 118) The other one, entirely crossed out in the original, announces: "In order to make the external form (style) agree with the general tonality the use of this paradoxical logic seems to me to be [*illegible*]." The two observations emphasize a concern for form, which inspires Duchamp's style in the Notes. The general external form will be that of the instruction ("recipes"), but also of description ("in order to describe"), that is, the two above-mentioned values of the neutral and the programmatic. (Observe in passing that these two values are rendered together as well by a turn of phrase like "one obtains the *tirés* by . . .", which is that of the so-called genetic definition in mathematics.) The "form" of the Notes will thus be maintained in the amphibology of the

two values. The latter is a paradox Aristotle even says sometimes: a paralogism. It's this amphibological form (neutral and deontic) that will be in "agreement" with what there is of paradox in the very logic of the enterprise. For a hinge-logic, a hinge-style.

This style is illustrated at once with the introduction of the neologism "ironism of affirmation." Ironism takes up "ironic causality" but modifies it. This word in -*ism* desig-nates a principle, a genre, and a school. Not the figure of such-and-such an enunciation, antiphrasis for instance, but a principle affecting any enunciation. Not a particular axiological modality expressing the reversal of values, but an entire genre of discourse. And not the spontaneous discovery of a potential speaker, but a systematic work of which irony is both the means and the goal, as impression is for Impressionism.

Which means among other things that the word is humor-istic by itself: if it is laborious, does irony deserve its name, is it efficacious?

But precisely ironism does not seek what is funny; its efficacy is not marked by the fact that it provokes laughter.

(Duchamp collaborated on a humorous magazine, *Le Rire;* the capital letter here on the word "Laugh" is a recollection of it, perhaps.) Laughter is born from the way the law, whatever it be, civil, divine, law of life, is turned aside and defeated without striking a blow, made derisory from a point of view that surpasses it, starting from a position that discovers its contingency; such is the negating part of funny irony. Such is, according to Duchamp, the insufficiency of the Dada movement: "Literary-Dada purely negative and accusatory"; "Literary-Dada opposed, and, by opposing, became the tail of that which it was opposing"; "What we wanted, Picabia and I," he adds, was to open "a corridor of humour . . . in full ignorance of or indifference to what, in art, had been done before us." (DDS, 248)

The ironism of affirmation is not transgressive, i.e., reactive. It invents legislations; it makes contracts. It does not tragicomically affront the law in order to denounce its arbitrariness. It loves the law's contingency. It calmly botches together *some laws.* And therefore it does not enter upon the field of laughter and weeping, or at least, if it does enter there, it's in order to detect the laws of these emotions and produce them and feel them in apathy.

Duchamp *observes,* in the two senses of the word: he respects his contracts with himself—that's the form of the instruction to be observed; he suspects them, examines them, puts them under observation—that's the style of description.

In general

1. *Project*: by "general hinge," we understand a set of approximate operations permitting the dismantling of a work, the *Glass,* and the reassembly of another, *Given,* starting from the elements of the first one. A hinge between two states. It does not play on the same flaps as the Boxes or the *Approximation: that can be dismantled*: the Boxes contain the (sporadic) notes and documents that surround the conception and realization of the *Large Glass;* the *Approximation,* an almost exhaustive set of instructions for assembling *Given,* comprises fifteen Operations intended to construct this work starting from the separate parts taken from the packing-cases of the hauler. (We know of no text analogous to the Boxes for *Given.*) The operations, intellectual, imaginative, and plastic, of the Boxes are situated prior to the production of the *Glass;*

those of the *Approximation*—"purely" technical ones— assume a finished work that has already been set up at least once (hence "that can be dismantled"), and are thus placed later than its production. Our hinge would come to operate between the first hinge, which articulates the Notes on the *Glass,* and the second, which analyzes the last sculpture by means of the last instructions. All that is very presumptuous.

2. *Definitions*: Hinge: group of operations, but acting "by ironic causality." (DDS, 46) Example: Bedridden Collars (*Cols alités,* 1959), pen of the *Large Glass* in his raised hand: Duchamp adds to it in pencil a power pole and two landscapes of hills, one on top, one below. Double irony: 1) collision of the figurative with the two regions of the *Glass,* which stem from one or several quite different plastic arts; 2) allusion, itself double and heterogeneous, to the secret work in progress: the insolent landscapism of *Given,* and the major and hidden role played in it by electricity. Ironic bedridden collars = hinges. These are straight lines (1-dim figures) common to at least two planes (2-dim), those of their flaps; they constitute the axis of symmetry of these flaps in space (3-dim). We know that two plane figures that are symmetrical with relation

Marcel Duchamp
Cols alités (Grasse, 1959).
Collection Robert Lebel, Paris.

to an axis (hence inscribed on the flaps) are not superimposable in the 2-dim, but only in the 3-dim by rotation. Likewise the hinge of symmetry of two 3-dim figures (for example two polyhedra, the two hands, two similar screws but with opposite threads: examples given by Kant) is a plane: these two figures are not superimposable in 3-dim space (you can't put a right-hand glove into a left-hand glove); they must be superimposable in a 4-dim region. Kant names this property of symmetries *incongruence*: space is humoristic.

3. *Examples*: A hinge in logic would be a paradoxical operator, its minimum property would be to stand in the way of one of the great operators of congruence, for example implication (if *p*, then *q*), which is the very serious logical causality. Would it be the case for an inclusive disjunction: and / or? *Monsieur Marcel and / or Mademoiselle Rrose. Door* (of the rue Larrey) *open and / or closed.* If man, then non-woman; but: if man and / or woman, what then? The *and / or* hinge appears to affirm the symmetry and the incongruence of the two terms. An equivalent in the theory of modalities might be: *it is contingent that it be necessary that* . . . ("the irony of having *chosen* [contingency]

the primitive body or object, which *inevitably* [necessity] becomes according to this perspective [or other convention]. . . .") (DDS, 55) A temporal equivalent: a current future taken as a current past; theme of speed in Duchamp, and its "solution" sought on the side of "a time of 2 dim, 3 dim, etc." (DDS, 130) A deontic equivalent: *it is obligatory to permit everything.* Etc.

4. *Pertinence* of the hinge for Duchamp, it sustains the tale and above all the spatial device of *The Bride* See in DDS, 130–137, all the "analogisms" of the passage from the 3- to the 4-dimensional with that from the 2- to the 3- : a rectangle turning like a hinge engenders a cylinder; imagine the hinge-plane of a volume (3-dim) engendering by rotation a 4-dim figure. The two transversals of glass that separate the Bachelor region and the Bride region are also generators of this sort. "Make a hinge-picture." (DDS, 42)

5. *Instruction*: Here it is a question of a meta- or a pata-hinge: between at least the two great works. Example and / or hypothesis: passage from the *Slide* (*Glider*) of 1913–1915 to the Trolley-slide of *The Bride,* and from this one to

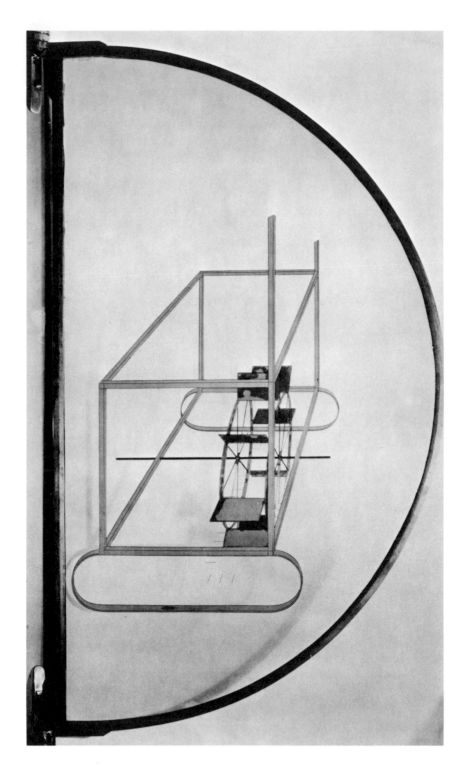

Marcel Duchamp
Water Mill within Glider (in Neighboring Metals) (Paris, 1913–15).
Philadelphia Museum of Art: The Louise and Walter Arensberg Collection.

the fame of *Given.* Duchamp's commentary on the *Slide*:
it "is also a machine sliding on its two runners." (DDS,
225) What he does not say is: the glass support of the *Slide*
is again a mobile panel articulated to the wall by two
hinges. Hence it is a represented Slide and/or machine
and/or articulated panel. The Trolley of *The Bride* is the
same object, likewise on glass. But the support is not mov-
able; it's the *Large Glass.* However, if you admit that the
lower transversal is indeed a hinge line or plane, the
Trolley (and the whole of the lower region) is virtually artic-
ulated by it to the upper region of the *Glass.* Hence the
instruction: the frame of *Given* (from the brick wall
to the background mounting) being supposed to be a
3-dimensional Slide-Trolley, "and also a machine":
find the hinge specific to this work or its absence.

6. *Intuition*: the hinge (or the group of hinges) of the *Glass*
is ascetic; with the transparency of the material, it contrib-
utes to its function of *apparition.* (DDS, 120–122) The for-
getting (?) of an analogous hinge in *Given,* joined to its
profound plastic opacity, makes of it a place of *appearances*
ibid.) and of seductions perhaps. What is the hinge
between the two devices?

The Glass

7. *Title of the* Glass, *the narrative*: Is the argument of the *Large Glass* a narration, as its title indicates? What the title (statement 1) does not say is this: *the Bride's Bachelors laying her bare, even* (2), which is the transformation of (1) into the active voice. There are many differences between the two statements; at least this one: *laying bare* indicates that it's in the course of happening in this time when I am speaking (the present of enunciation); *laid bare,* which might be the substantive (the Stripped-bare Bride), leaves a hesitation: is the Bride in the process of being laid bare as I speak? Has she already been laid bare? Once or several times? Does she remain naked after having been undressed? Questions in a confessional style that take the lexical given back-to-front: in French, *the bride* exists only for one day and one night, on the day before, she is the virgin, on the day after, the wife. By contrast, bachelorhood is a state. Another difference: in (1), the statement is focused on the bride; linguistically she could do without an adjunct of agency; whereas the bachelors of (2) have a definite need for an object to complement their action; they are linguistically more married than the bride (the reason for the possessive, her bachelors?). And for (1) and

(2): *the bride,* does that mean this one here that I point out to you, or the one, whoever she may be, of whom you can think? The second version, which in general wins the day, classifies the title (1) on the side of the allegorical (of the type: Liberty leading the people). So is there a story? Rather the heading of a "scene" or of a "tableau vivant," in Sade's sense, with the two properties of this genre: 1) it's a fragment or an embryo of narration (like the images in some "Thematic Aperception Test"); 2) it's an illustration for a pedagogic discourse (the school of libertines in Sade) conducted in parallel with it. Imaginative function and ascetic function.

8. *Title of the* Glass, *the logical*: The word *Even* will make a bit more ink flow here. It would appear to be a floating logical operator. Duchamp has affection for this family; "given that . . ."; "if I assume that I be suffering much . . ." (DDS, 36: Box 1914); "on condition that (?)" (DDS, 47); "Given (*in darkness*) 1st the waterfall; 2nd the illuminating gas," taken up again as: "Let there be, given *in the darkness* . . ." (DDS, 43: Green Box); or again: "If a horizontal straight thread . . ." (DDS, 36, 50: Box 1914, taken up again in the Green Box). These are always the hypothetical propositions of an implication: if p (then q).

But either the implied proposition is missing or else it takes a programmatic form: given x and y, "it will be determined etc. . . ." The implication thus remains suspended from a future problematic; it will depend on what you will do (and so we have, not: If p then q, but: If p then q; and if p [= if it works]; then . . .). *Even* would appear to be an operator that is likewise incomplete, but indicating both the concession or reinforcement of the adverse argument and its retortion. Would she be *even* laid bare (as you assume); or: *even* if they were her bachelors; or: assuming *even* that there be any bride (= *if any* *): the concession accepts the adversary's argument and even its reinforcement, which aggravates its content. But the two retreats band together to turn it back (retortion): well, now, that's just it . . . ; it's even / just for that reason that. . . . The first sophists knew well this procedure of the eristic technique. Duchamp's retortion anticipates the objection: but because they are bachelors . . . ? Well, exactly, they will remain so, *even* if they were to screw her; all this being flat (adj. *even* *: uniform, equal, flat, smooth, at the same level, etc.).

*In English in the original

9. *Title of the* Glass, *the paradoxical*: Pay attention to this: "Henceforth starting from *Le Buisson* [1910–1911], I was always going to give an important role to the title which I added and which I treated as an invisible color." (DDS, 220) The titles of works do not indicate their content or meaning, or not only. They are added to them; they are not engendered from the story that they represent. Nor have they an indexing function in relation to a system of genres, in this case pictural ones. They are supposed to operate on the spectator in the same way as a color. But this color is invisible. One can certainly practice "the raising of colors" like the raising of fruit, "only the fruit still has to avoid being eaten." (DDS, 100) Duchamp wants colors that are unconsumable by the eyes, "a certain inopticity, a certain cold consideration." The colors of the *Glass* will be only "the colors of which we are speaking" (DDS, 118), "past participles" and not "present participles" (ibid.). If the title can act as a color, it's because the color acts as a name (of a color). Inasmuch as it is colored, the picture is a statement, at least a combination of names denuded of meanings, in a word: a title. The title of the *Glass* is a color, it is the work, or a part of the work. And the colors of the work act as its title. Thus the title is doubly paradoxical: it has no more affinity with the content of

the work than the colors have with the parts of the work that they color: the arbitrariness of signs, though they are supposed to be realist ones, especially when they are visual; besides, the words that form them form a part of the ensemble constituted by the colors, but the colors form part of the ensemble formed by the words: tautology, or paradox of the class of all classes.

10. *Title of the* Glass, *hinge*: articulating, then, three panels: a narrative function that can be broken down into a pedagogic (allegorical) function and an imaginative (erotic) function; the logical function of a floating operator; a paradoxical function of tautology or self-reference.

11. *Notes of the Boxes, descriptions*: Follow what the story becomes in the Notes of the Boxes. (There must be a chronology of the notes, to be established: some of them in the Green Box are dated 1913, 1914, May or September 1915, and in the White Box: 1913, 1914, December 1915. Others can be dated by external criticism, the rest by internal criticism, graphological analysis, perhaps. One could examine whether the importance attached to the narrative function changes; for example, whether it

decreases as the work progresses.) The Notes are reflections or indications of manufacture. Both aim to produce visible plastic figures; they are induced by the scene of the heading. But the induction passes via a poetic mediator that is almost a genre, that of analytic description. Between the story and the figures inscribed on the *Glass,* heroes are broken down into viscera, then into parts of machines (down below, mechanical and chemical ones; up above, electrical ones); the Note gives the description of a part and its functioning. Thus, two narrative states: an embryo of a general story, the Bride, etc.; local descriptions (of the type: "the trolley would be made out of rods of emancipated metal" DDS, 81), which will lead to the projections in the proper sense onto the *Glass.* Between the two, arbitrary and necessitating decisions; the Bride will be one single internal combustion engine; the Bachelors will be multiple reservoirs for assorted gases from a whole transformation workshop. These decisions move the descriptions away from anatomy-physiology toward descriptive geometry, dynamics of forces, and metageometry. By these decisions, the descriptive implications receive the mark of "influences" (geometrism, anticubism, etc.) and of obsessions and ingenious strokes.

Thus, two extreme flaps: the story, the figures of the *Glass,* and between them, a double hinge: the decisions made in the field [*les décisions de champ*] with the area prior to them (the "influences"), and the descriptions of the parts.

12. *Final Notes, speculations*: Finally, in the Notes published in the last phase (White Box), the hinges devour their panels. And even the reflections on the decisions (those involving n-dimensional geometry) devour the descriptions of parts and arrangements. The stage empties. There is little to be seen; "there is a certain inopticity." (DDS, 118) Toward abstraction? But the chronology of the Boxes is not necessarily that of the writing of the Notes. . . .

13. *The* Glass *and its story*: And yet the Notes and the *Glass* will remain hooked onto the Scene, even if only by the title. Why the title? Is it an added "invisible color," that of sex? Is it a consideration given to the function of the story, even the most elementary one, in relation to time, namely to indicate that something is happening, or is going to happen (event)? Is it to incite the looker to look on the side of sex, and is it in order to trap him at it? Yes, yes

and / or yes. The story is indicative of movement; this movement is not noticeable immediately. And it's the case for any event (when something happens, the something does not give itself up at once for what it is, or else nothing happens). Eroticism is the common (in) experience of the passing of an event, indicated in many titles: *Surrounded by Swift Nudes, The Passage from Virgin to Bride.* Narration furnishes the a-chrony of the *Glass* with a horizon of paradoxical story, the pornographic excitant of the stories vis-à-vis the figures (like the *Historiennes* of the *Hundred and Twenty Days* are for their listeners, the practitioners).

14. *Complexity of the Bachelor story*: the Bachelor workshop is organized according to a chronology of production. Like any factory, it orders the transformations to which a given or a raw material is subjected—in this case the gas, of unknown origin—until it is sent out, in the form of a finished product, toward the organs of the Bride in the upper region. Beside this narrative sequence, made sufficiently explicit by Duchamp, there is another mechanical complex, quasi-independent of the first one, corresponding to the story of the making of a second product, milk chocolate, starting from a chocolate "coming from who knows where." (DDS, 96) This product is not sent to any-

Sur une logique infinie, prenons deux points
A, B ~~...~~ A comme charnière
faisons tourner AB. AB engendrera
une ~~surface~~ qc. c.à.d. courbe, brisée ou
plane.

autour de AB comme charnière
faisons tourner la surface plane
elle engendrera un volume
Donc un continu fini à 3 dim.
est engendré par un continu fini
à 2 dim. en tournant (au sens
général)
autour d'une charnière ~~...~~
~~...~~ dans un esp à
1 dim.

Marcel Duchamp
Note. A facsimile published
in *A l'infinitif,* Cordier &
Ekstrom, New York, 1967.

On an infinite line let us take two points, A, B. Let us rotate AB about A as hinge. AB will generate some sort of surface, i.e. either curved, broken or plane.

Let us rotate the plane surface ABCD about AB as hinge. It will generate a volume.

Thus a *finite* 3-dim'l continuum is generated by a *finite* 2-dim'l continuum *rotating* (in the general sense) about a finite 1-dim'l hinge.

where. Finally, in the last plan of the *Glass,* we find associated with the chocolate-grinder a third complex. It was supposed to be set in motion by a waterfall falling onto the blades of a mill whose rotation drove the shaft of the chocolate-grinder and indirectly governed the movement of a Trolley on a slide toward the chocolate grinder. A weight (Bottle or Hook) falling on strings attached to the Trolley had to draw it toward the right of the picture, and a pulley connected to the shaft of the mill had to raise this weight again while the Trolley was brought back to its initial position by rubber bands, situated, therefore, "at the left of the picture" (DDS, 83) or, perhaps, by a principle "of inversion of frictions." (DDS, 82) The waterfall, the weight on a rack-and-pinion system, the ropes, and the rubber bands were never executed. The outward trips of the Trolley are aleatory movements (the weight that governs them being "of oscillating density" [DDS, 86–89]); the return trips are made without entropy (DDS, 81, 83); the whole thing produces nothing but "litanies." (DDS, 81, 82)

15. *Simplicity of the Bachelor space*: Thus, in the same lower workshop, three productive processes, mechanical sub-tales, the one "useful" having its outlet onto the client

above and independent of the two others (if one ignores the role of the scissors); the last two stories by contrast subjected one to the other by the shaft of the mill, but independent of the Bride region and of the production of the gas. In other words, a richly narrative panel with two and / or three internal hinges (if independence is a hinge). But the spatial figuration of this same workshop is, on the contrary, profoundly homogeneous, entirely governed by classical perspective. Duchamp established the plan and elevation of the figures in the workshop (DDS, 60, 61); perhaps like Piero he constructed a mock-up of the workshop. The lower region is, in all its parts, the perspective projection onto the plane of the glass a deep cube arranged around one single vanishing point; the latter is placed on the horizon line formed by the lower edge of one of the two rulers, the lower one, which separates the two regions. (Note that four of the Malic Molds are placed outside the virtual cube, at the left, and brought back into the frame of the glass by perspective alone: a question to follow up with regard to *Given*.) The classicism is confirmed in the composition of the figures: "Rectangle, circle, square, symmetrical loop, demisphere." (DDS, 66) But here is the value that Duchamp gives it: "The *principal forms* of the bachelor-machine are imperfect . . .

= that is, they are measured" (ibid.). All their relations have been calculated with a view to an optical unity: such is their imperfection. The unifying projection for the eye of the 3-dim into the 2-dim is thus a deficiency. Why? Because the hinge of the 3-dim with the 2-dim is then without secret: it is visible, congruent. The eye remains master of its objects. The deformations to which these figures are "forced" are easily corrected; they are not powerful dissimilations. The plastic panel of bachelorhood is spatially poor, lacking a paradoxical internal hinge (if one ignores the transparent material).

16. *Unity of the Bride-tale:* The Bride-apparatus presents a different disequilibrium: a unified productive story, multiple spaces. The female machinery has as its model the internal combustion engine; among others, the stripping bare is that of the poles, more or less, of an electric circuit, it generates the spark that makes the gas explode. (DDS, 62–66) The top and the bottom are opposed to each other like two technologies, the second being traditionally mechanical, the first being modern and working by electrical transmission, an opposition that is transcribed in a plastic way: the Bride-machine is not placed in the same space as the Bachelor workshop.

17. *Heterogeneity of the Bride-space:* But first this space
is not homogeneous in itself. Here you must pass again
through the story of production. The explosion is none
other than the "blossoming" of the woman; (DDS,
62–65) "all the graphic importance is for this cinematic
blossoming"; it is "the most important part of the pic-
ture . . . the halo of the Bride." (DDS, 62–63) But the
combustibles are of two sorts: the desire of the Bachelors
(gas given off in the cylinders) and the wilful imagination
of the desiring Bride. This second principle of blossoming
is something done by a "magneto-desire" or a "gear-train
desire" (DDS, 63–65), whose mistress-cog is housed on
the left of the upper part inside the *Pendu femelle* and is
called the "standard driveshaft"; by contrast the cylinders
stuck in the flesh of the Milky Way, a "superficial organ"
(named in the first Notes as "breast cylinders"), open out
(DDS, 64), in any case: also (DDS, 65) owing to the explo-
sions of the gas "fired" from the Bachelor workshop. To
these two principles of functioning correspond two dif-
ferent plastic graphisms, "completely" different, whose
"mixture," whose "physical compound" is "unanalysable
by logic." (DDS, 64) Duchamp says of Arp's Concretions
that they are often like "puns in three dimensions . . .
which," he adds, "is what the female body could have

been" (DDS, 195): such would be the virtual physical compound of the upper region. The upper space is thus not isomorphic in all its points, and the two complexes of the one machine are represented according to different plastic modalities: the forms on the left (*Pendu femelle*) derive from an organization that is cubist in style, tri-dimensional but seen from an "exploded" point of view; on the right we are dealing with an abstract modulation of depth, obtained by a wavering (the silhouette of the Pistons was given by squares of gauze fluttering in the wind) or by a game of skill (the fired shots are the traces of nine shots aimed at one single target and stopped by one single screen). Chance plays a role in the making of these "principal free forms" (DDS, 66–67), which are not "measured" in relation to their destination. If there is projection—and there is projection—it is not thinkable according to the canons of the *costruzione legittima*. Its principle comprises the play of an uncontrolled variable in the heart of a group of defined constraints: chance and precision.

18. *Homogeneity of the Bride-space:* And yet the forms of the top together obey a general principle of projection, in no way incompatible with their heterogeneity: To put this

heterogeneity together with that principle, it is enough to admit that we cannot represent to ourselves the laws of this projection. If the woman-machine is a 4-dim object, and if we do not know how such an object inscribes its form in a 3-dim space, well, then, you can assume that the (nonetheless incongruent) plastic properties of the *Pendu femelle* and the Milky Way are so many "examples" (DDS, 66–67) of possible effects of such a projection, which is nevertheless unique in its principle. The plastic organization of the workshop down below excludes all allusion to a 4-dim area: the Bachelor is 3-dim and he remains so, even when he is projected onto a surface (3-dim virtual). But when you come back up again from the 2-dim projection of the organs of the Bride to her supposed 3-dim body, you do not meet this body, but only the dispersed and incongruent organs the *Glass* offers us; you would have to add to it another dimension in order to attain the true body; but you cannot imagine this body visually. A double spatial hinge that completely conceals one of its flaps.

19. *The large hinge, the lower transversal:* But the large plastic hinge of the *Glass* is the group of transversals. The stories make of them a Cooler for the surges of the Bride and the Bachelors, and they fix on its line some apparatuses of

which we know one, the Boxing Match, from the Notes (DDS, 94–96) and the other, the Gravity Handler, from a reconstitution (which we owe to Jean Suquet).[1] These apparatuses, not executed on the *Glass,* open passages between heteromorphous spaces: from the point of view of the tale, they are sufficient to forbid us to read the *Glass* as a tragedy of errors or of the separation between men and women. If you stick to the plastic point of view, they emphasize the remarkable polyvalence of the transversal. It is made from two glass rulers placed side by side, determining three horizontal parallel lines. The line below is the horizon line of the Bachelor workshop. It bears the vanishing-point that organizes its perspective. It is therefore a line in the (2-dim) plane of the glass, at the same time as the hinge of two planes (earth and sky) in virtual space (3-dim). As for the point, it marks 1) the intersection of all the lines of flight, traced but effaced, on the 2-dim surface of the glass; 2) the intersection of the orthogonal issuing from the viewer's eye with the same real plane; and 3) the intersection of this same orthogonal with the horizon line making a hinge between sky and earth in virtual 3-dim space.

[1] *Le guéridon et la virgule,* Paris, Bourgois, 1976.

20. *The upper transversal:* Duchamp names it Clothes of the Bride in a sketch in the Notes. (DDS, 95) That's for the tale. But plastically? It is obviously the lower edge of the frame of the Bride-space seen by the real 3-dim eye of the viewer. But it must still be something quite different, if it is true that on the top surface is inscribed a 3-dim (virtual) projection of the unknown 4-dim figure, that of the woman.

Here let yourself be "influenced" and obsessed by the same sources as Duchamp when he takes his narrative and plastic "decisions." Jean Clair has established that Pawlowski's book of science fiction, *Journey to the Land of the Fourth Dimension,* was such a source.[2] And he shows elsewhere the influence of Duchamp's readings of *n*-dimensional geometry, in particular of Jouffret (DDS, 127), who brings him the theory of cuts that came from Dedekind via Poincaré.[3] The latter writes: "In order to

[2] *Marcel Duchamp ou le grand fictif,* Paris, Galilée, 1975.

[3] "Marcel Duchamp et la tradition des perspecteurs," in *Marcel Duchamp, abécédaire,* National Museum of Modern Art and National Centre of Art and Culture, Paris, 1977.

divide space, you need cuts which are called surfaces; in order to divide surfaces, you need cuts which are called lines; in order to divide lines, you need cuts called points; you cannot go further and the point cannot be further divided, the point is not a continuum; so lines, which can be divided by cuts which are not continua, will be continua with one dimension; surfaces, which you can divide by cuts which are continuous in one dimension, will be continua with 2 dimensions; finally, space, which can be divided by cuts which are continuous in two dimensions, will be a continuum of 3 dimensions."[4] From which it follows: An area that can be divided by cuts that are continuous in three dimensions will be an area having 4 dimensions. Compare that with this speculation: "Razorblades which cut well and razorblades which no longer cut. The former have 'cuttage' [*du coupage*] in reserve. Make use of this 'cuttage' or 'cuttingness' [*coupaison*]." (DDS, 47) A plane is usable for cutting in 3-dim space, but it no longer cuts in a 4-dim area, exactly as a point, usable for cutting a line; it is no longer so usable for a plane, and just as a line, usable for cutting a plane, is no longer so usable for a 3-dim space.

[4] *La valeur de la science,* 1st ed., p. 74.

The "same" geometric figure thus sees its operative power diminished when it is placed in a continuum possessing one dimension more than the one in which this power was intact. But if one is interested only in powers, like Duchamp, one will say rather: the point is to the line as the line to the plane, etc., and as the volume is to the 4-dim. Here we have a general law of projection, from which can be deduced (very seriously) that what is a line in a plane is the trace of a plane ("seen from the side") situated in a 3-dim space, the same as a plane in a 3-dim space can be the projection of a 3-dim volume situated in a 4-dim space.

You can thus go back to the upper transversal of the *Glass* and say: It is a line in the plane of the glass, but it is also the profile of a plane in the virtual 3-dim space of the upper region, but because this plane is itself the projection of a 3-dim volume situated in the 4-dim space where the true body of the woman is, this line is thus also the trace (2-dim plane) of the trace (3-dim volume) of a power that is usable for cutting only in a 4-dim area. If we call this cutting figure "4-dim angle," we can say after Duchamp: "For the representation of the angle,[4] two mirrors intersecting each other (at an obtuse angle) represent 2 spaces intersecting each other on [?] a hinge-plane. For the

eye[3], in space[3], this hinge-plane is visible only at its cut with space[3], i.e., the intersection line of the two mirrors. *The hinge-plane of the two spaces[3] is hidden behind this line* and the impression is clear for the eye[3] which is moving from right to left without ever being able to grasp a little [?] of this plane." (DDS, 131) Understand: this line that hides the hinge plane also hides (even more?) the *hinge volume,* which is necessarily an angle in a 4-dim area.

21. *The median transversal:* Now: why attribute this property only to the upper line of the transversals? For the lower line, no Note or declaration permits us to suppose that the Bachelor space was conceived as a trace (to the second inferior degree of power) of a 4-dim figure, and it is consequently certain that its horizon line, the lower transversal, does not represent to the real 3-dim eye of the viewer anything other than a line or the profile of a plane. What remains enigmatic is, then, the intermediary transversal, formed by the line of contact between the two glass rulers. For it makes a hinge between two symmetrical and incongruent hinges: one of them, the one below, of 2-dim and 3-dim function, the other one having 2-, 3-, and 4-dim function, and this is the upper one. Of course it articulates as its two flaps, two plane projections of two

3-dim virtual spaces, and in this regard it operates like the hinge of a mirror with two faces forming an obtuse angle. But it articulates also as its two flaps two (virtual) 3-dim figures, of which one, the lower one, has as its model a figure accessible to the 3-dim eye (visive perspective), and the other, that of the Bride, refers to an unknown and strictly invisible figure, and in this way it operates not only as a 4-dim hinge between two homogeneous 4-dim spaces, but as a ?-dim hinge between a space whose dimensional power is 3 and another (above) whose dimensional power is 4.

Paradoxical hinge. It marks both the separation of the top and the bottom and at the same time their symmetry and incongruence. It is not enough to make the lower region pivot around *its* hinge (horizon line) in order to bring it to superimpose itself on top of the upper region; you would have to raise it by one degree of dimensional power, and even then the two regions will remain incongruent in the ordinary sense, like the right and the left in relation to a vertical axis. It is this final incongruence that will have to be removed by an unimaginable pivoting "around" the median hinge, the only figure in the *Glass* to claim yet another supplement from 4-dimensional area—just as you

have to add a third dimension and the corresponding operation (rotation about an axis) in order to defeat the incongruence, in the plane, of two triangles that are symmetrical in relation to the line corresponding to this axis.

22. *Program:* Then to examine whether this spatial sophistication of the transversal hinges finds an equivalent, or its contrary, in the micro-tales and the apparatuses that they translate in the same region of the *Glass:* Cooler, Boxing-Match, Handler of Gravity.

23. *Program* (continued): It would remain to establish the hinges internal to the *Glass* meanwhile, making a pivot between all the narrative hinges and all the plastic hinges.

24. *Asceticism* has three mainsprings: the arbitrary nature and the illusionist function of perspective (projection down below of the real 3-dim onto something 2-dim with the effect of virtual 3-dim) are pedagogically demonstrated by the transparence of the support alone; the eye is discountenanced by the intervention of the 4-dim up above; representation is chucked out on the scrap heap by the median hinge.

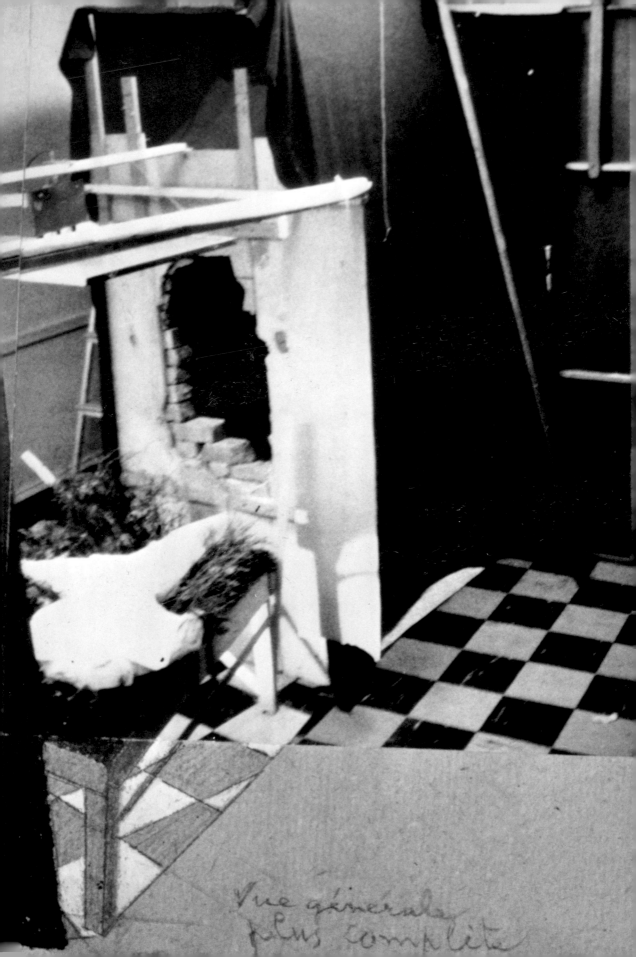

Vue générale
plus complète

The last nude

25. *The addressee of the Instructions, the machine-operator:* As a commentary on *Given,* we have only some assembly instructions. They are entitled: *Approximation which can be dismantled, executed between 1946 and 1966 in New York.* And under this title, in brackets: "(by approximation I mean a margin of ad libitum in the disassembly and reassembly)." The reader of the Instructions will find that the margin is narrow: among the numerous adjustments specified by the fifteen required operations, the only ones left to his discretion are that of the position of the clouds in their box of sky and that of the round lamp that will illuminate from behind the transparent waterfall. The text of the *Approximation* is not addressed to imaginative intelligence, but to skill and faithfulness of execution. The *Glass* is a picture its viewer must make (DDS, 247); *Given* is a collection of spare parts a handyman must reassemble. In the Notes of the Boxes, Duchamp talks to himself and to everyone; the Instructions are intended for the set designers, propmen, and electricians of the theater where the scene of the nude is played. There's no longer even any need for a director to conceive it, merely a need for hands to make it.

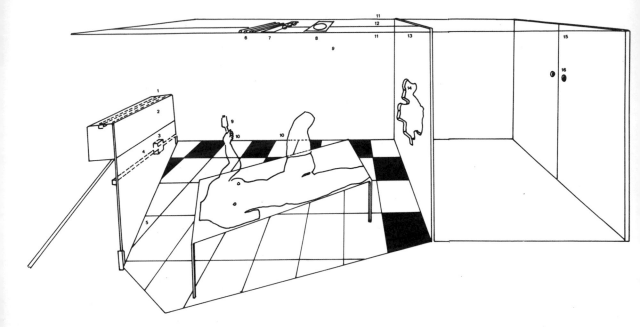

Etant donnés (1946–1966). Attempted reconstruction of an isometric view. N.B.: The heights have been roughly halved.

1 Fluorescent for the sky.
2 Sky-box.
3 Motor and lamp for the waterfall.
4 Landscape.
5 Squared linoleum.
6 Three fluorescent lights.
7 Three lamps.
8 Spotlight.
9 Auer jet.
10 Added left arm and leg.
11 Red light.
12 Green light.
13 Brick wall.
14 Breach.
15 Wooden door.
16 Voyeur's holes.

(Anne d'Harnoncourt, Director of the Philadelphia Museum of Art, kindly allowed me to study Duchamp's manual of instructions for the assembly of *Etant donnés*. This reconstruction and the two following are not reproductions and are intended merely as an aid to reading.)

26. *The addressee of* Given, *the voyeur heir:* The Boxes refer to a *work in progress,*[*] unfinished, perhaps unfinishable, delayed; the Instructions are those of a last will and testament: it is finished, I have made it, you can only remake it, and here's how. It's finished and ready, "ready made."[*] The executor has only to carry out the prescriptions of the testament. The testamentary discourse belongs to the performative genre: I designate as my sole heir Monsieur X; and by the fact of this declaration alone, Monsieur X becomes the sole heir. It differs from the other performatives in that its efficacy concerns the constitution of the beneficiary, and especially in that this is subordinated to the definitive disappearance of the enunciator, who has to be dead. As for the heir who is designated here, after the testament has been opened and suitably executed, he is a viewer of a special kind, called the "voyeur" in the Instructions. He will have the pleasure of the legacy, an obscene reclining figure opened to his eyes, untouchable as in a pornoscope, and that he will not in any way be able to make prosper and "blossom out." The same authority that prescribes to the reader of the Instructions what he has to do fixes for the viewer of *Given* his position and his

[*]In English in the original

role: thou shalt not touch, thou shalt not turn about the gaping pudendum, thou shalt not even move in front of it; on the contrary the *Glass* and the Notes of the Boxes required of the spectator and the reader the greatest agility, the most tenacious mobility of the eyes, of the body, and of the mind.

27. *Transference of the tale onto the image:* To this immobility that corsets the body of the viewer and transforms him into a voyeur, there corresponds the complete disappearance, in the *Approximation,* of the tale (albeit precarious) and of the descriptions and plans that accompanied it in the Boxes. User instructions for machine operators, expurgated of all narration, prepare an insolently figurative scene. It's the inverse relation to that of the Boxes to the *Glass,* where the scene suggested by the elementary tale of the stripping bare, which is given by the texts, is disfigured (defiguratived) into insensate mechanical linkages and derealized by the transparency of the support. It is insufficient, and in part inexact, to say that the visible machinery of the *Large Glass* passes behind the scenes of *Given*; it is notable on the other hand that the narrative function (albeit a deficient one) provided by the Notes on the Boxes is transferred to the visible scene of

the last work. If a story is told here, it is no longer to the reader; it's to the voyeur. The story is no longer written; it's up to him to tell it to himself; the story is virtual.

28. *First group of hinges* between the two ensembles: creation in progress *versus* execution after the fact; speculations for themselves and in themselves *versus* prescriptions to cause others to observe; a narrativized discourse *versus* an executory discourse; a non-figurative flattening *versus* a realist volume. The hinge thus appears easy to determine and logically not at all paradoxical: it's a group of strong exclusive disjunctions. The last work would resolutely turn its back on the one before.

29. *Decisions residing in the title:* And yet we are dealing with a story, and the same one here as there. *Given: (1) the waterfall, (2) the illuminating gas* (note that Duchamp's written form always places the 2 under the 1, and not beside it) is a fragmentary quotation from a Note in the Green Box (1934: DDS, 43–44), which presents itself in two versions: one entitled "Preface," the other, "Foreword." This general title is furthermore converted into two subtitles: *"Given the illuminating [lamplight] gas"* (DDS, 76) introduces to the tale, extended over several Notes,

some transformations undergone by the gas; *"Given the waterfall"* (DDS, 89) forms the title of a unique Note that bears two sketches, one of a "Water mill (landscape)," the other of "A sort of water-jet arriving from far away in a semi-circle—over the Malic Molds." That Duchamp should pick this Preface or this Foreword as the title of his last work implies several decisions: 1) its title will be more logical (see above, paragraphs 7–10) than narrative, which goes along with the elimination of the tale in the writing; 2) referring to a previous foreword touching on the problematic that presided over the making of the *Glass,* he announces its resumption from zero, its recommencement; 3) this problematic of the Foreword being of a theoretical nature, the title of the last work will have to link the specular device of his sculpture with the earlier speculations; and 4) "water" and "gas" both belonging to the Bachelor region of the *Glass,* the title will indicate that in spite of appearances, the space where female intimacy is exhibited fully is that of men alone.

30. *Explanation of the title:* The text of the Green Box is dominated by the photographic analogy: "Snapshot rest . . . best exposure of the extra-rapid Sleep [of the extra-rapid pose] . . . extra-rapid exposure" on the one

hand, and on the other "Given (*in darkness* . . ." taken up in "Let there be, given *in darkness* . . ." these terms circumscribe a problem: that of the impression of a sensitive surface, plunged into darkness, by luminous rays emanating from the contrary movements of a waterfall and of a combustion of gas. The exposure-time or pose-time will have to be extremely short. Duchamp's interest in the fixing of movement on a surface is not new; it governs his studies from 1911 onward. Let us note only that after some attempts inspired by time-lapse photography, he turns toward a solution that one could call a-cinematic, and whose axiom would be: for a very fast mobile object, a very short exposure time and an image denuded of signs of movement.

A first insufficient approximation. The contrary movements of fall and rise (water and gas) give place to "a succession [an ensemble] of diverse facts seeming to necessitate each other mutually by laws," or else to "several collisions seeming to succeed each other rigorously one after the other following laws." Thus it's not the movements that must be fixed on the sensitive surface, but their collisions (or "criminal attempts"); or more precisely, the sequence of these collisions. This sequence is

Préface

Étant donnés 1° la chute d'eau
2° le gaz d'éclairage,

on déterminera
nous déterminerons les conditions,
du Repos instantané (ou apparence allégorique)
d'une succession [d'un ensemble] de faits divers
semblant se nécessiter l'un l'autre
par des lois, pour isoler le signe
de la concordance entre, d'une part,
ce Repos (capable de toutes les excentricités innombrables)
et, d'autre part, un choix de Possibilités
légitimées par ces lois et aussi les
occasionnant.

Par repos nist ant ane = faire entrer
l'expression extra rapide

On déterminera les conditions de [la] meilleure
exposition on Repos extra rapide [de la
pose extra rapide (= apparence allégorique
d'un ensemble etc

Marcel Duchamp
Note titled *Préface* published in facsimile in the Green Box, New York, 1934.
Typographic version reprinted by permission of Hansjörg Mayer, London & Jaap Rietman, Inc., New York.

Given 1. the waterfall

 2. the illuminating gas,

 one will determine

we shall determine the conditions

for the instantaneous State of Rest (or allegorical appearance) ?

of a succession [of a group] of various facts

seeming to necessitate each other

under certain laws, in order to isolate the sign

 the

of accordance between, on the one hand,

 all the (?)

this State of Rest (capable of innumerable eccentricities)

and, on the other, a choice of Possibilities

authorized by these laws and also

determining them.

For the instantaneous state of rest = bring in

 the term: extra-rapid

We shall determine the conditions of [the] best

exposé of the extra-rapid State of Rest [of the

extra-rapid exposure (= allegorical appearance).

of a group etc.

un Peut être.

Avertissement

Étant donnés [dans l'obscurité] 1°- la chute d'eau
Soit, donnés 2°- le gaz d'éclairage, dans l'obscurité

détermine, devra

on (déterminera (les conditions considérations de l'exposition
extra rapide (= Reproduction apparence allégorique) de plusieurs
collisions semblant se succéder rigoureusement
[attentats]
chacune à chacune (suivant, des lois) pour
isoler le (Signe) de la concordance entre cette
exposition extra-rapide (capable de toutes les
excentricités) d'une part et le choix des possi-
bilités légitimées par ces lois d'autre part.

Comparaison algébrique

$$\frac{a}{b}$$

a étant l'exposition
b " les possibilités

le rapport $\frac{a}{b}$ est tout entier non pas dans un
nombre c $\frac{a}{b}=c$ mais dans le signe (−) qui sépare
a et b ; a et b étant sont connus, ils deviennent
des unités nouvelles et perdent leur valeurs numériques relatives (ou de durée)
; reste le signe − qui les séparait (Signe de la
concordance ou plutôt de ?... cherche)

Marcel Duchamp
Note titled *Avertissement* and *Comparaisons algébriques* published in facsimile in the
Green Box, New York, 1934. Typographic version reprinted by permission of Hansjörg
Mayer, London & Jaap Rietman, Inc., New York.

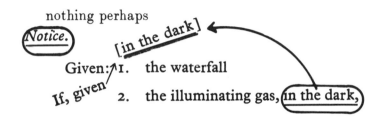

nothing perhaps

Notice.

[in the dark]

If, given

Given: 1. the waterfall

2. the illuminating gas, in the dark,

consider considerations

we shall determine the conditions for the extra-rapid

organization allegorical Reproduction

exposition (= allegorical appearance) of several

collisions seeming strictly to succeed

[assaults] unnecessary

each other according to certain laws, in order to

the

isolate the Sign of accordance between this

extra-rapid exposition (capable of all the

eccentricities) on the one hand and the choice of the possi-

bilities authorized by these laws on the other.

Algebraic comparison

 a a being the exposition

$$\frac{a}{b}$$

 b b ,, the possibilities

the ratio $\frac{a}{b}$ is in no way given by a

 (-)

number c $\frac{a}{b}$ =c but by the sign which separates

 as soon as are

a and b; a and b being "known,, they become

new relative

units and lose their numerical value (or in duration);

 of ratio

; the sign \rightleftharpoons which separated them remains (sign of the

 ?

accordance or rather of look for it)

constituted by a succession of contacts ("diverse facts") between water and gas; it is not a simple movement, namely a relation between a space and a time, but an (apparent) second degree movement, constituted by the relation between the time taken by the series in its entirety and the diverse spatial positions that result from each of the collisions. In such a movement, time seems to submit the diversity of the figures of the water/gas contact to rigorous laws, for the whole set suggests the unity of a consecutive order.

There comes then the statement of the project properly speaking: because the conditions of the optimum pose-time for fixing the time of the sequence of collisions are "determined," one can isolate "the *sign of the concordance* between this ultra-rapid exposure (capable of all eccentricities) *on the one hand* and the choice of the possibilities legitimized by these laws *on the other hand.*" Shortly after, it is explained that if you call the exposure a and the said possibilities b, the sought-for "sign" is to be identified as the bar of the relation a/b. Which makes the statement of the Foreword fairly tautological, for the exposure is none other than the pose-time, and the choice of possibilities consists first of all in determining the spatio-temporal

parameters (like duration, frequency, amplitude) of the
succession of collisions, i.e., the "laws" that constitute it
as such. So much so that by replacing the values by the let-
ters *a* and *b* corresponding to them, you get: Determine
the *a* of *b* in order to isolate the sign of the concordance
between *a* and *b*. And developing this: Given a succession
of encounters between the contrary movements of water
and gas, determine the exposure-time that is in concor-
dance (but the word will be rejected) with the temporal
parameters of the series of these encounters.

Because it is a question of recording a series of diverse
facts, it is legitimate to think that the pose-time will not
be a simple duration of exposure, but a rhythm determin-
ing the alternation of the openings and closings of the
objective lens to the light rays emanating from the series.
Which brings us back to the time-lapse photographer and
to the cinematographer. And Duchamp thought of it:
"To make a sculpture-picture like you would wind a reel of
cinema-film—at each turn, on a large reel (several metres
in diameter if necessary), a new 'shot' continuing the pre-
vious turn and linking it to the following one" (DDS,
107); but he adds: "This continuity could have nothing in
common with that of the cinematographic film, or resem-

ble it." The decisive question is to know if the surface bearing the photograms must be seen in movement or at rest; it is enough for it to be animated and with a movement identical to that of the filming, in order that there be created in the eyes of the viewer the illusion of the real movement (that of the collisions). This illusion implies that there is no longer any perceptible "sign" of any "concordance" between the time of the pose and the time of the recorded subject. But if the surface of inscription preserves together, immobile, the impressed traces, not only will this sign remain perceptible, but it will appear as what determines the (henceforth "allegorical") appearance of the "real" movement. And that is why the "laws" of the collisions merely "seem" to legitimize the "choice of possibilities." They are, in fact, just as much "occasioned" by it, for the characteristics of the filming organize the subject (in this case the series of collisions) just as much as the other way around.

But the *Glass* is indeed this isolated sign, an immobile sensitive surface (retina) on which the diverse facts of the story come to be inscribed, according to the possibilities meticulously chosen by Duchamp, and such that the

viewer will have literally nothing to see if he ignores them. But what about *Given*?

31. *Inversion of the relation between appearance and apparition:* The last work appears, on the contrary, to efface this sign and to show only the sequence or story of the collisions. Its plastic art seems to contradict its title perfectly, if you take it in the sense just given. This is something you will understand more easily if you remember that in the Foreword the pose is said to be also "appearance." Duchamp constantly opposes the appearance of an object to its apparition. The appearance is "the ensemble of usual sensory data permitting us to have an ordinary perception of this object" (DDS, 120); the apparition is the "(formal) mold" of the appearance, for example, the 2-dim image in perspective of a 3-dim object or else its "(photographic) *negative*." The relation *a/b* of a moment ago is that of appearance and apparition, respectively. The *Glass* shows the apparitions of the appearances; it is like the negative of the two sets of objects, Bachelors and Bride, which, moreover, derive from different spaces. *Given* appears, on the contrary, to offer merely the appearance of what it makes us see. What the viewer sees on the *Glass* is the eye

and even the brain in the process of composing its objects, the images of these objects impressing the retina and the cortext according to laws of (de-)formation, which are their own and that organize the glass partition. But when the voyeur puts his eyes in the holes of the Spanish gate, he seems to have only an "ordinary perception" of the objects he sees. The *Glass,* being the film, lets us see the conditions of impression that reign on the inside of the optical box; *Given,* being this box regulated as to its field, shows the external objects that appear there to be seen from its inside (dark chamber).

The dominant function in the respective titles is inverted with regard to the one that governs the plastic works: this being a narrative function for the ascetic work, a logical one for the work of seduction. If the logical is to narrative as the apparition is to the appearance, one will say that the apparitions-picture bears an appearance-title and the appearances-monument an apparition-name. The hinge of exclusion between the two works thus operates in this double register also. But it functions in both directions, and as the titles are no less important than the works that bear them, this reversion forbids us to take the illusionist montage of *Given* as a banal seduction-trap.

32. There follows a *series of operations forming hinges between the trolley of the* Glass *and the frame of* Given: The hypothesis is that the *"bâtis"* [a—frames] (Duchamp writes it like that, why?) of *Given,* which occupies, encloses in itself, and opens up a 3-dim space, the volume of which is not without analogy to that of the trolley of the *Glass,* is a Bachelor machine. (And that it is its own Box unto itself.)

a) This trolley *"presents itself dressed up as Emancipation, concealing in its bosom the landscape of the water-mill."* (DDS, 88) In the *Glass,* only the mill is visible, not the water or the landscape. In *Cols alités,* the landscape emerges. In the last work, the landscape and the waterfall, if not the mill, are in full light, as a backdrop. You recall that the water jet had to come from the back of the Bachelor horizon in order to come falling down onto the foreground, into the frame of the trolley. The scenic space of *Given* would be framed in something like the right-angled parallelipiped of the trolley (although this is not exactly the case; but the hypothesis is merely heuristic). It would have as its horizon the landscape, here coming forth from its hiding place.

b) The vanishing point of the "cube" (in the perspectivist sense) of *Given* would be given by the vulva. A slightly plunging perspective, the voyeur's eye being placed higher up (at a height of 1.536 meters) than the table that supports the nude; it's the inverse of the relation of the respective altitudes of the Bachelors and the Bride in the *Glass.* But the position of the vanishing point would be verifiable only by photo (which the *Approximation* frequently invites us to do).

c) The double partition, the portal with the two voyeur's holes and brick wall with its indentation, would be the analogue in the Bachelor space of the double partition of the Cooler that separates the top and the bottom of the *Glass.* "This cooler will be a transparent glass. Several panes of glass on top of each other." (DDS, 59) Here, where the machine functions only on the horizontal, the said panes of glass would be one behind the other, like the lens elements of an optical apparatus, which we must therefore imagine placed on the holes of the door and in the breach in the wall.

d) The imperceptible interstice crushed between the two transverse panes, i.e., the transverse median line of

the *Glass,* would have as its analogue the dark chamber that in *Given* separates door and wall: the door is the Bachelor horizon of the *Glass*; the wall is the Clothes of the Bride, or, respectively, the lower and upper transverse line. This immutable distance nails the eyes to their viewing point and the woman to her optimum point of exhibition (vanishing point). The voyeur is a viewer without dimension, reduced to his point.

e) The holes in the door and the breach in the brick wall: the Boxing Match opened the Bachelor horizon by raising the two rams that close it, with shots of a marble (with glances),* and the Clothes of the Bride, supported by these rams, have been unhooked. The Boxing Match is a "lubricious gear-train." (DDS, 59) Not executed in the *Glass,* it is not visible in *Given* because it is what makes for seeing.

f) But for an instant only: a spring was meant to close up the orifices by making the rams fall back again. This spring marks the fate reserved here for the voyeur: he

* "en soulevant les deux béliers qui le ferment, à coups de bille (d'oeil) . . ."

sees suddenly, in the snapshot of the opening of the diaphragm. Because of this he sees no more than is seen by a sensitive film, he is impressed, like the film. *Augenblick,* point in time, no time at all.

g) The perimeter of the diaphragm is given by the irregular contour of the breach. "On the coupling of these two appearances of pure virginity [that of the stripping bare by the Bachelors, and the wilful-imaginative one of the Bride]—on their collision depends the whole blossoming. . . ." (DDS, 63) The breach would result from this collision. It determines the frame of the appearance; it is the mold or the apparition of the blossoming. But there are eyes only for the blossoming.

h) If the door corresponds to the Bachelor horizon line of the *Glass,* and if the waterfall that was meant to come falling down into the foreground onto the mill is thrown back into the background in the last work, it's because the lower space is here taken back to front: the voyeur looks out from the equivalent of the lower transversal line, from the "upstage" area of the *Glass,* in the direction of its downstage area. He ought to see . . . the viewer of the *Glass.* The astonishing thing is that he sees the

woman who ought to be both behind him and above him. In any case it was necessary that she should fall.

i) The device would be specular (and no longer "mirrorish"). The plane of the breach would be that of a picture that would cut the visive pyramids that have as their summits the voyeur's holes. In an organization of this type, the viewing point and the vanishing point are symmetrical: If it is true that the latter is the vulva, then the vulva is the specular image of the voyeur-eyes; or: When these eyes think they see the vulva, they are seeing themselves. A cunt is he who sees.

j) But the plane of this perspectivist picture remains virtual: there is no glass nor any support in the breach in the wall on which the plane projections of the 3-dim nude would really be inscribed. There, of course, is where Dürer's gate would be installed, as Jean Clair suggests.[5] Just as it's in the place of the eye-holes that the camera should be placed if one wanted to photograph the scene (after the upper panels of the door have been moved aside

[5] Article cited, pp. 157–159.

on their runners: fifth Operation of the *Approximation*).
What's left is that the window pane is not there.

k) The black-and-white squared lino placed on the
ground of the scene is entirely invisible, as the squaring
must be that serves to set up the perspective in Alberti and
the others. As the axis of sight on the nude is plunging,
the background plane bearing the sky, landscape, and
waterfall will have to be set up leaning a bit toward the
back ("angle with the ground, 91° or 92°," *Approxima-
tion,* p. 2). Duchamp thus reopens the angle that this
plane forms with the visual rays, in order to hollow out the
depth of the field. * In Vicenza, Scamozzi raises the floor-
boards of the *vedute* of the Teatro Olimpico to obtain the
same effect. Something else to be entered to the credit of
the illusionist: a slight inclining of the nude on the table
toward the front (to be verified).

l) Perspectivist hinge: the 3-dim real (subject) is pro-
jected on something 2-dim and real (support); the latter

*Possibly a pun: "pour creuser la profondeur du champ" suggests a
"Duchamp profundity" being increased.—TR.

Etant donnés (1946–1966). (Reconstruction by J.F.L.)
N.B. The measurements in meters are either those given by Duchamp or else have been calculated from those that he gives in inches. The measurement for the depth is 1.6 meters.

1 Mounting for the background, supporting the sky, landscape, and waterfall.
2 Figure
3 Brick wall and breach.
4 Black chamber.
5 Wooden door and voyeur's holes.
6 Museum gallery, empty.

gives an optical effect of 3-dim (virtual: appearance). Hinge of *Given*: the 3-dim real (the subject that is the nude in the bushes, and the space of the stage) would give an optical effect of 2-dim (virtual: the surface of a support placed in the breach, but non-existent).

m) To be corrected. Duchamp's hinge in the bottom part of the *Glass:* it's the perspectivist hinge with a supplementary articulation. The virtual 3-dim of appearance gives an optical effect of 2-dim (because of the transparence of the support and of the treatment of the figures analogous to that of an architect's "blueprint"). Duchamp's hinge in *Given*: the virtual 2-dim is treated in order to produce an optical effect of 3-dim virtual, according to the model of the stereoscopic device (D'Harnoncourt and Hopps)[6] or anaglyphic device (Jean Clair).[7] This model requires two eye-holes, not one. A further allusion to this model: the fact that the frame is supported in its length by two red girders and the spotlight lighting up the sex is sup-

[6] *Etant donnés: 1° a chute d'eau, 2° le gaz d'éclairage. Reflections on a New Work by Marcel Duchamp,* Philadelphia Museum of Art, 1973.

[7] Article quoted.

ported by a green transversal stand. This chromatic opposition refers to the postcards with a stereoscopic effect, like *Pharmacy* (1914), but equally to the *traffic lights** of the railway from Paris to Rouen: it thus indicates as well the elementary poles of kinematics, movement, and rest.

n) In comparison to the fantastic hinge of pluri-dimensional spaces that demultiplies the *Glass,* the derisory stereoscopic fantasy of *Given.* Over against that asceticism turned against visual habits and in the face of that severe machinesque pedagogy, here we have the pornography of voyeurism and furtive exhibitionist machination. Beside the rigid orthogonals of the *Glass,* there is the irregularity of the breach in the wall and that of the pentagon formed by the theatrical space in which the nude is placed (see following, section 47).

o) In the *Glass,* the sensitive film receiving the impressions was the glazed surface itself; in *Given,* it's the eye. Reversal of in-front-of/behind (see *h,* above). Furthermore, the film of glass ostensibly bore the marks of the conditions of exposure and impression to which it

*In English in the original.

was subjected; and thus the *Glass* was not only the film but also the recording apparatus with all its implied settings. In the last work, these conditions are invisible like the apparatus; this apparatus governs vision.

p) Hence the reversal of the times. That of the viewer is expended and "retarded" in the movements of eye, of body, and of intelligence necessary for penetrating the *Glass*: the work is enveloped in the long duration of crossing networks. For the voyeur of *Given,* nothing is left of such a time, no need for screens to fall, for angles of sight to be corrected in order to manage to distinguish. There's nothing left for him to do but to see all at once and on the spot, pitilessly. Furtiveness, suddenly in vain, is struck down in a flash.

q) But then *Given* would not break at all with the asceticism of the gaze that the *Glass* was seeking. It would accomplish it in the very place where the *Glass* misses it, in the temporal order, that is, the desire to take and to identify by sight: The stupidity of this desire accomplished photographically would be more radical than the intelligence of the same desire postponing endlessly, speculatively, its own accomplishment. More radical in terms

of asceticism in relation to the senses (meanings, sensitivities, sensualities) than is the "Huguenot" critical rigidity—such would be the pagan scene.

33. *Hinges bearing on themes, elements, and materials, the disabled nude:* The 3-dim nude of *Given* is incomplete: the head is formed of two smooth shells; the right upper arm, the ankle, and the right foot, the left foot are missing. However, the same object appears complete to the eye of the voyeur, the absent parts being hidden. The Bride, for her part, is "incomplete": genital apparatus and breasts. But the two incompletenesses are not congruent: the one is masked by the dead angles of the framing and the screens of the decor; the other proceeds from a perfectly visible plane deconstruction. The two women are disabled, and both by projection, but the woman of the *Glass* because her 4-dim model is untranslatable in perceptual space, the stage-woman because it's impossible for her voyeur to get around her. Metageometry on the one side, lack of mobility on the other. Irony there, humor here?

34. *The collapsible doll* has assembly hinges that must be masked: "This joint [of the left leg] with the hip which

is not very precise will be hidden by branches and dead leaves" (12th Operation of the *Approximation*); "The joint to the elbow, being too visible, will be hidden by the bush no. 4" (13th Operation); the wire supplying power to the electric lamp that serves as a gas mantle is "to be hidden under the arm" (ibid.). The hank of hair, fixed to the head by a clothes peg and falling over the breast, allows the joint of the neck to be concealed. It's not only the framing but the accessories of the decor that must efface the fact that the nude can be dismantled and reassembled. If the woman in the top of the *Glass* was in separate parts, her construction didn't make a mystery about it.

35. *The dumped dummy:* The nude is hollow. A "dorsal spine" constitutes its hidden armature on the inside. It rests on its table at three points of impact (like the Juggler of Gravity: see DDS, 46; like the Chocolate-grinder?) and a movable panel of which it is said: "When it [the nude] is in place, raise the panel hinge which holds up the bar (dorsal spine) without thrusting too much" (11th Operation). The light molding, being thus suspended as is the Bride, must, however, produce on the eye an "effect of being thrust into the bushes" (10th Operation). These bushes will appear to envelope her; some of them will

even be fixed to her sides instead of being fixed to
the table.

36. Obscenity: The *Pendu femelle* and the Milky Way are
aerial. Mobility is their origin and their destination. The
nude is crushed in the bushes. After having described the
two heterogeneous desires that contribute to the blossom-
ing, Duchamp notes in the Green Box: "The last state of
this [naked, *scratched out*] Bride laid bare before the plea-
sure which [makes her fall, *scratched out*] would make her
fall (will make her fall)." (DDS, 64) The woman enjoys,
so she has fallen into the 3-dim Bachelor space, and that's
what her nudity is. Or, if she is visible in this space, it can
only be as naked, and then we must believe she takes
pleasure.

The vulva that you can't fail to notice—it's all you see—is
denuded of all hair (whereas the armpits are hairy—this
isn't a child); the thighs are spread apart; the erect large
labia are open. They let us see not only the tumescent
small labia but also the gaping orifice of the vagina and
even the swollen vestibulary bulbs around the lower com-
missure. The vulva looks up? Or, the vulva-full looks up?
[*La vulve élève la vue? ou: la vulvée lève la vue?*] A second

thought of Duchamp attracts us in the direction of the second: "15th Operation: *General adjustment* . . . the hair (change to dirty blond) . . ." (*Approximation*), while the photos of the first assembly show a brilliant mane of chestnut hair.

37. *Speed:* In a word, it's a "swift nude." A propos of *The King and the Queen Surrounded by Swift Nudes,* Duchamp says: "The title 'the king and the queen' was borrowed once again from chess, but the players of 1911 (my two brothers) have been eliminated and replaced by chess pieces (king and queen). The 'swift nudes' are a flight of fancy introduced to satisfy my preoccupation with move-ment, a preoccupation that was still present in the pic-ture." (DDS, 223) Here there remains only the queen, who is mated (or checked)* at a stroke on the lino chessboard. "Swift," that is, instantaneous, a snapshot [*instantané*]. "Plastic duration, time in space." (DDS, 109) The interminable striptease of the Bride expends an infinity of time in the eyes and the head of her viewers;

*faite mat (ou *mate?*)

the undressing determines a delay. The nudity is, on the contrary, punctual, a flash just after something and just before something.

38. *Hinges bearing on themes, etc., continued, the bushes:* Displaced pubic hair? "Abominable abdominal hair?" Or else: playing truant [in French, *l'école buissonnière,* suggesting bushes]? Or else: return of the *Buisson* (1910–1911), allegory of two women, naked, one on her knees, under the age of puberty, the other a matron, standing up, chaperoning the first one, the two of them sisters? A burning bush that is allegorical of the passage from virgin to bride? From the *Buisson* dates the new importance given to the title: invisible color added to the picture. (DDS, 220) Or the bushes of the invisible winter landscape of the *Bride,* its "frosted branches" (DDS, 64) signaling the cold opposed by the woman (but the foliage of the landscape is of high summer)? Or simply, the bushes are to conceal the joints and to screw our vision onto the vulva? Or again: they aggravate the hairlessness of the cunt? Or: all of that at once. Or: a little of that. Hinge to be demultiplied more knowingly. In any case the bushes launch many tales.

39. *Continued . . .* : The landscape appears to derive its design from *The Moon of 21 August 1953* (D'Harnoncourt and Hopps). But the *Approximation* provides for an effect of sun on landscape. For its material it derives from the *Glass:* it contains chocolate (and talcum powder: milk chocolate). In the Notes of the Boxes, chocolate is the object on which the difference between appearance and apparition is thematized, notably the chromatic difference (see section 43 following). In this sense chocolate is at least the autonomous color par excellence, which owes its (invisible) tint only to itself. In *Given,* it ceases to be a theme for illustrating the problem of apparition. Its matter alone is "cited," and even then very allusively. And the landscape that does the quoting is placed under artificial light and reduced to being merely appearance. This appearance is substituted for apparition as matter is for chromatism and as the space of sensory areas is for that of machinic speculations.

40. *Continued . . .* : The waterfall was not executed on the *Glass,* and that was by way of ascetic strategy: "I didn't bother to represent it, so as to avoid falling into the trap of landscapism." (DDS, 225) It is a prominent part of

Given, constructed according to the method of music-hall machines and illuminated advertising signs. Painted on glass, it is lit from behind by a lamp whose light is diffracted by a plastic veil; the impression of flowing is given by the rotation of a circle of aluminum punched with holes and placed between the lamp and the other side of the glass support. Glimpsed at a bar in a small California town, an advertisement for Coors beer promoted the coolness of its brewing waters by showing a water cascade animated according to the same principle; the object seemed old. Duchamp alludes to "luminous advertisements" (DDS, 101), but in order to illustrate the idea of apparition. They are examples, just like the waterfall, of appearance-machines. Two remarks: 1) The disk alludes to optical machines, in particular to the "rotative demisphere" and to the roto-reliefs: but they were optical paradoxes, whereas the assembly of the waterfall is a visual trick effect. 2) The waterfall is a force, in the *Glass,* and it was no more represented than any of the other sources of energy that the tales of production apply to the top and bottom machines. *Given* makes it pass over to the state of a visible animated figure while all trace of the energy that animates and illuminates it, electricity, is effaced on the

stage—a doubled hinge that twice over pulls down appearances over the apparitions and plunges us into the most spectacular of the senses.

41. *Continued . . .* : *The sky* of the last work is a pane of glass like that of the Milky Way. But this pane is one side of a hermetically sealed box whose rear side is a piece of blue cardboard that contains a fluorescent lamp and clouds made of cotton wool (placed *ad libitum* by the assembler against the partition of glass or on the cardboard backdrop). The blue of this sky is thus a color of appearance whose light is supplied by an artificial source and whose tint is obtained by a reflector. And this tint is that same blue that the Notes on the *Glass* recommended to "avoid . . . in mixtures because of its imbecile atmospheric tendency." (DDS, 113) As for the wadding of the clouds, it's another allusion: to the breast cylinders, which became Milky Way, which Duchamp for a time thought of making, if not with cotton, at least with shaving soap. (DDS, 108) But here, too, the appearance eclipses the apparition.

42. *Hinges bearing on lights, colors, materials: The gas,* material for the stories of the *Glass,* is here represented as

luminous energy; the Auer jet is the only lighting whose source is visible from the voyeur's holes. Yet it is merely appearance: like all the lights of *Given,* that of the gas burner is electric. Electricity was feminine in the tales of the *Glass,* and gas was masculine. In the narrations that the scene from behind the door suggests to the voyeur, there will be no question of electricity: the only personified energies are water and gas, as the title says. The assembly instructions do not cease to deny the virtual stories provoked by the spectacle of *Given*; the tales collected in the Boxes guide the viewer of the Bride. It is thus confirmed that the narration passes over to the side of representation, and the text, to the side of the machineries. But let that not make us forget this: In this double inverted passage, narration becomes virtual and machinery invisible.

43. *The same hinges: Color in general* is treated here as an appearance. This is what Duchamp calls the color that an object receives, the chromatic apparition being on the contrary "in native colors" (DDS, 121), those "which are found in molecules." To tell the truth, these latter "are not colors . . . they are luminous foci producing the active colors—i.e., a native-chocolate surface will be com-

posed of a sort of chocolate phosphorescence"
(ibid.). They are "colorant light sources and not differen-
tiations in a uniform light (sunlight, artificial light, etc.)."
(DDS, 117–118) The properties of such foci necessarily
escape the eyes, which know only appearances. They are
graspable only by the intelligence: *"There is a certain
inopticity, a certain cold consideration, this colorant affecting
only imaginary eyes* in this exposure." (DDS, 118) It's in
having recourse to the lexical, in keeping away from any
visual experience, that one must manage to conceive
"equivalents" of these active colors, "which are not seen"
(DDS, 110): "the colors of which one speaks." "I mean,"
explains Duchamp, "the difference which exists between
the fact of speaking of a red and that of looking at a red."
(DDS, 118) It's for this same reason that conversely Du-
champ looks for a transcription of the alphabet and even of
"grammar" into colors or into photograms, in which the
Inscription from the upper region must be written. (DDS,
48, 109–111) It's also why in the Notes of the Green and
the White boxes he often uses German to designate the
shades. In the *Approximation,* the rare notations of color
are made in English. Is it the sign of a persistent interest in
the chromatic apparition? For the use of the machinest-
electrician perhaps, certainly not intended for the voyeur,

who is doomed to uniform and artificial lights, to local shades that captivate the eye, to the most connoted chromatisms: to all appearances.

44. *The same hinges: The particular colors* on the stage of *Given* are, besides the blue of the sky, pink and green as in the anaglyphs. Page 20 of the *Approximation* bears the outline of the overall electrical assembly. The Bachelor green: "Auer jet: a round lamp-glass, inside: a gas-jet mantle and in the mantle a small electric bulb, painted green to give the illusion of gaslight." The pink of the Bride: "Above the nude, three fluorescent lights: 1) a very white daylight, 2) a pinkish daylight named '4,500 white,' 3) the same; each one of 40 watts." In the White Box (DDS, 116), the Bride already (but it's perhaps still the bride of the *Passage from Virgin to Bride* of 1911) has pink as her "leitmotiv" ("obtained by Silver White and Lichtocker Gebr") [light burnt ochre]; by contrast the Bachelors are doomed to the "dark," into which Prussian blue always enters, and sometimes green. And yet one cannot say that the chromatic register is preserved in *Given*; the only things that are preserved are the appellations of the colors corresponding to the two poles; for the eye of the voyeur, the scene of the nude shines white-pink

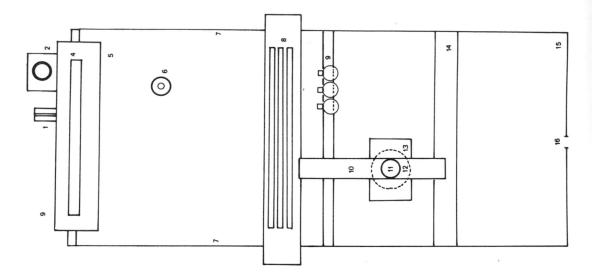

Etant donnés (1946–1966). Attempted reconstruction (by J.F.L.) of the lighting plan.
N.B. Neither the shape nor the proportions of the frame have been respected.

1 Motor that moves the disk.
2 Biscuit tin.
3 Round fluorescent lamp.
4 Sky-fluorescent.
5 Landscape.
6 Auer jet.
7 Red bars.
8 Three fluorescents (40 watt each), one very white, two pink.
9 Three lamps (150 watt each).
10 Green bar.
11 Spotlight (150 watt), which "must fall vertically, precisely on to the cunt."
12 Aluminum reflector.
13 Glass pane.
14 Brick wall.
15 Door.
16 Voyeur's holes.

with all its lights. The pale fallen body in the 3-dim frame
of the males inundates it paradoxically with the blazon of
its tints. And the color worn by the Bachelors, far from
irradiating their space, is only a pitiful halo. Thus in terms
of shades, the hinge between the two works 1) nominally
maintains the respective blazons of the two parts; 2) makes
the dominant color from the top region of the *Glass* pass
into the space of *Given,* which is the analogue of the space
of the lower region of the *Glass*; and 3) eclipses the domi-
nant color of the latter. The voyeur has eyes only for the
colors of the woman; his own are excluded from his field.

45. *Same hinges: The lighting* comes from two sorts of
sources: spotlights and fluorescent lights. Both can be
attenuated by diffraction through transparent screens or
reinforced by reflectors. The rays of the fluorescent lamp
that light up the transparent waterfall are yet further soft-
ened by a "film of plastic" (15th Operation). The whole
background of the scene is subjected to a "cool white"
light. At the height of the navel of the nude, the lighting
is more than brutal, aggressive: three fluorescents of
40 watts each, three "Century lights" of 150 watts each,
finally "a spotlight" of 150 watts equipped with a reflec-
tor of aluminum, so intense that a transparent glass placed

above it intervenes to "protect the nude from the heat."
This last lamp, notes Duchamp in the assembly schema
(*Approximation,* p. 20) "must fall vertically, accurately, on
the cunt." A "shade" made of white plastic will, in addi-
tion, be "mounted separately from the general frame,
which serves to enclose the lights and to reflect them with
more intensity onto the whole" (15th Operation). And to
reinforce the brightness of the scene, the antechamber
placed between the door and the broken-down wall is
upholstered with black velvet on four of its six sides (6th
Operation). The whole system of lighting is thus made so
as to seize hold of the eyes of the voyeur and lead them
without delay to their supposed focal point, the vulva.
In the *Glass,* Duchamp is in search of an "electricity in
breadth" and of a "retarding in glass"; here he fires a
flash, a *punctum electricum,* which gives the snapshot of
a scene in "permanence."

46. *The same hinges . . .* : We would have to examine fur-
ther how the *materials* are transferred from the *Glass* to
Given, and to distinguish the constitutive materials of the
Glass and those of the workshops from the primary parts
and the raw materials of which the tales in the Boxes speak
and for which Duchamp seeks to establish a system of

chromatic translation (of the type: "Steels White, yellow, black, ochre, dark background. . . . Aluminium White, Prussian blue, yellow, ochre). . . ." (DDS, 114) The same in *Given*; distinguish the construction materials and the materials on the stage. One would probably find the same operator as before between the two groups: the constitutive materials are hidden in the last work while the *Glass* exhibits them, those that are associated with the production stories are mediated by the techniques of "apparition" in the *Glass,* those that give place to the narrative fantasies of the voyeur of the nude are made up for purposes of "appearance."

47. *The volume of the frame* should also be studied in hinge with the plane of the glass. The perimeter of the linoleum defining the surface of the stage is not rectangular, it's an irregular pentagon, whose three obtuse angles seem to open a corner into which the angle of the nude's table will come to be lodged. The nude is presented obliquely in relation to the axis of the frame (check whether the eyeholes of the door aren't themselves pierced obliquely, in the axis in which the sex is located, and not in that of the tiling). A part of the body spills over, then, outside the cube of the stage, as was the case for four of the Malic

Molds, as the plane view of the Bachelor Machine shows. (DDS, 61) There is also the oblique of the partition that bears the landscape, which moves it away from the perpendicular to the general axis, in the other direction, toward the right. The hinge question would be: what about this overall obliquing? Wherein does it contribute, it too (along with the lighting, with the irregular frame) to narrativizing the scene? A nude enters the field from the left; like the Bride of the top part of the *Glass,* it inscribes its mute commands in space according to the same direction as writing (?).

48. *"Solutions"*: Is there a general meta- or a pata-hinge between the two works? 1) *Tale*: the woman of the upper region lets herself be taken, she loses her fourth dimension, she falls. This is the obscenity. 2) *More machining tale*: the Bachelor thinks he's got the woman open in his vizor, but he's the cunt. 3) *Meta-tale of expressive inspiration*: the nude in the field, * it's my body, and "besides, it's always the others who die," just as my epitaph declares, my tomb is necessarily empty, I shall never be dead, the frame is my cenotaph. 4) *Meta-tale of expressive inspiration that can be assembled together with the preceding one*: besides, you will not know me; you thought me an ascetic,

and here I am dressed up as Emancipation. 5) *Speculation*: in order to kiss/fuck [*baiser*] the eye, you can delay it, the procedure of the *Glass*; you can go faster than it, snapshot procedure. But you are ascetic in both cases. 6) *Speculation that can be assembled with the preceding one*: you can go faster than the eye, not through asceticism, but through paganism. That is: Duchamp understands that in working on the 2-dimensional projections, even of 4-dimensional objects, he does not at all emancipate himself from the critique of the senses that is the metaphysical obsession of the Platonic and Christian West—he continues it. If with *Given,* he affirms representation-narration in all its humoristic force (anaglyphic humor), it is not in order to denounce the illusions in the Cave, nor even the illusion of the Cave, but in order to say: that projection is not worse than another one, it is just as good, because there are only projections.

Any putting into perspective, including that of our most trivially mass-media optic, is the imposition of an order based on *faits divers*; the interesting thing is that this order has no reason or principle. The hinge made by the point-of-voyeur with 3-dimensional space is worth as much as the meta-geometric hinges, for there are only hinges. Not

the edifying paganism, then, that will win out over Rome under the name of catholicism, but that of theatrical games, which the former kind destroyed and that were devoted to simulating the metamorphoses of the innumerable divinities. Not Plato, but Ovid and Apuleius. Not Kant, but the later Nietzsche. 7) *Ironism*: "Give always or almost the why of the choice between 2 or several solutions (by ironic causality)." (DDS, 46) Which one, then, of these hypotheses about the meta-hinge, and why? Neither of them, a different one, many together, almost. 8) *Objection to 6 and reply*: how can you distinguish between humoristic narration-representation and credulous narration, and how can you decide about the one that Duchamp bequeaths to us? Thanks to this, that his artificialism appeals to the power to detect everywhere in "realities" the putting into perspective that forms them, a putting into perspective that is both necessary and contingent. And to invent others. 9) *Compendium*: you can say all that *ex tempore.* That is, the laying bare: before it, the body is hidden from the gaze; after it, it is exposed to it. It is the instant of transformation or metamorphosis of this before into this after. It is graspable only as this limit. So: two "solutions." That of the *Glass,* where the gaze comes

always too soon, because the event is "late," the *corpus*
remaining to be stripped without end. With that of *Given,*
it's the gaze that arrives too late, the laying bare is finished,
there remains the nudity. Now makes a hinge between
not yet and no longer. That goes without saying for any
event, erotic, artistic, political. And does not give place
to mysticism.

Table

Illustrations

Endpaper film Marcel Duchamp. Detail from a study (New York, 1948–49) for *Etant donnés*. Moderna Museet, Stockholm.

Endpaper Marcel Duchamp. Study (ca. 1950) for *Etant donnés*. Gouache on perforated clear Plexiglas. Private Collection, Paris.

Frontispiece Man Ray. Photograph of Marcel Duchamp as Rrose Sélavy (Paris, 1920–21). Philadelphia Museum of Art: Samuel S. White III and Vera White Collection.

Fold-out The door and the interior tableau of *Etant donnés* (New York, 1946–66). Philadelphia Museum of Art: Gift of the Cassandra Foundation.

Photograph by Marcel Duchamp showing the interior construction of *Etant donnés*. From the manual of instructions for the assembly of *Etant donnés*. The Philadelphia Museum of Art: Gift of the Cassandra Foundation.

Rear endpaper Marcel Duchamp. Study (New York, 1948–49) for *Etant donnés*. Painted leather over plaster relief within velvet surround. Moderna Museet, Stockholm.

Printed in the United States of America by Gardner Lithograph.

Works by Marcel Duchamp are reproduced with permission of Mme. A. Duchamp.

The translation has been assisted by a grant from the French Ministry of Culture.

Originally published as *Les transformateurs Duchamp*
© Editions Galilée, 1977

ISBN 0-932499-63-5

The Lapis Press
589 North Venice Blvd.
Venice, CA 90291

Sam Francis
 Publisher

Ian McLeod
 Translator

Robert Shapazian
 Editorial and Visual Direction

Patrick Dooley
 Design

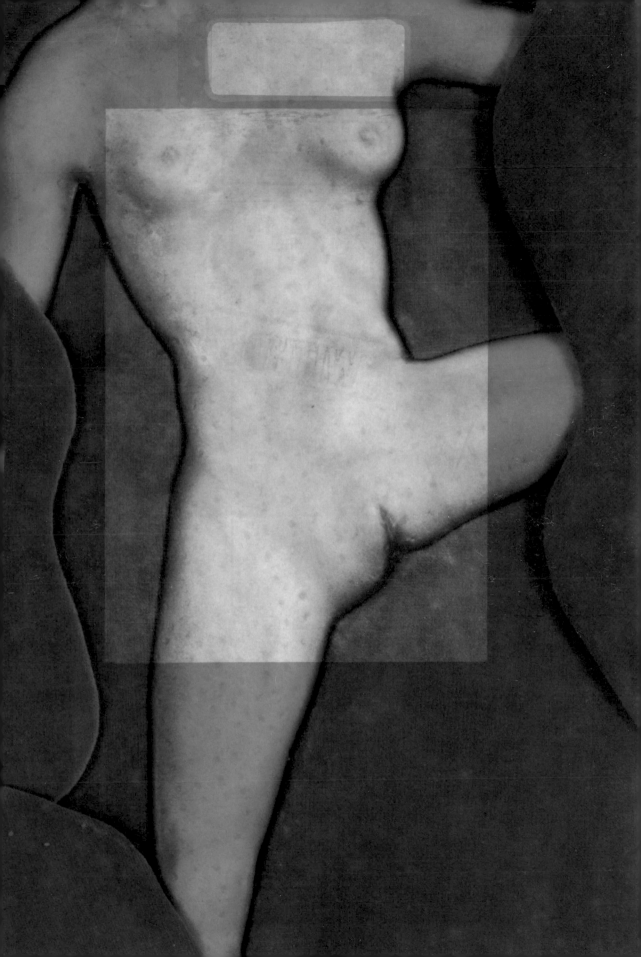